Brilliant Inks

Brilliant Inks

A STEP-BY-STEP GUIDE TO CREATING IN VIVID COLOR

Anna Sokolova

DRAW, PAINT, PRINT, AND MORE!

QUARRY

© 2022 Quarto Publishing Group USA Inc.
Text and images © 2022 Anna Sokolova

First Published in 2022 by Quarry Books, an imprint of The Quarto Group, 100 Cummings Center, Suite 265-D, Beverly, MA 01915, USA. T (978) 282-9590 F (978) 283-2742 Quarto.com

10 9 8 7 6 5 4 3 2 1

ISBN: 978-0-7603-7451-1

Digital edition published in 2022
eISBN: 978-0-7603-7452-8

Library of Congress Cataloging-in-Publication Data is available.

Page Layout: Megan Jones Design

Printed in China

To my family

CONTENTS

INTRODUCTION

I'm standing in front of a myriad of tiny mysterious bottles and tubes, and I have no idea how to use them. I feel irresistibly drawn to the medium, their allure promising endless possibilities.

But I'm feeling overwhelmed by the choices and the prices of the materials. I also have an unsettling notion in my mind that to create a good piece of art, I must combine the finest art materials in some special secret manner only professionals would know of. Which is, of course, totally false—creating is all about your personality, dedication, and practice.

And then I saw inks.

Just one bottle of violet ink, one brush, and that was it! For the price of a cup of coffee, I had a golden key to a whole new world I could never imagine.

That was me in an art store in St. Petersburg, Russia, many years ago. I was studying publishing and avidly absorbing all the art practice advice I could get. Strolling along the streets, I soaked up the artistic atmosphere in both the State Hermitage Museum and the Dostoevsky district. I could stare at Ilya Repin's painting *Sadko in the Underwater Kingdom* for so long it made the museum steward suspiciously question my intentions. I still practice the same behavior in Berlin's Museum Island nowadays.

Since that time, my work has evolved and bloomed, but surprisingly, the very core of my style hasn't changed. And that's the most incredible news for any artist—your personal style, your unique voice, is already there, right from the very beginning.

I hope this book inspires you to try new things and discover what you love. If drawing fine lines doesn't make you feel comfortable (even after lots and lots of practice), have no fear! There are tons of art styles and mediums to help you express yourself even better, more suitable to your character and personality, like bold and loose abstraction, collage, printing, lettering, photography, bookbinding, crafting, creative writing, or digital painting.

In this book, you'll focus your attention on the creative use of colored inks. You'll explore a variety of materials and techniques that will help you get familiar with the medium and bring your ideas to life. You'll draw flowers and birds inspired by the natural world and then move on to people and objects. Playing with vivid colors and shimmering special effects, you'll discover the world of fashion and still life.

Do you want to unlock your imagination? Create an illustrated accordion book version of *Alice's Adventures in Wonderland*. With room to experiment, what could be more fulfilling? I'm also thrilled to share a monotype technique with you. You'll create a unique piece in minutes, even without any experience.

Feel free to jump in anywhere in the book. If you can regularly devote just a few minutes to practicing some of the lessons from the book, I guarantee you'll feel immediate improvement in your art techniques.

You'll be amazed by the things you can create. Cherish your individuality—that's what the art world needs from you!

1

ALL THINGS COLORED INK

Ink has been a favorite of many great artists, yet there are still so many mysteries left to discover.

Colored ink is a broad term that can relate to many types of inks and mediums, such as printers' inks, tattoos, and markers. In this book, we'll focus on the liquid form of colored inks that can be used with pens and brushes.

Let's explore all the magical types of colored inks that are perfect for a contemporary artist.

TYPES OF COLORED INKS

Every type of ink has its own unique personality and special properties. We'll focus on the liquid form of colored inks that can be used with brushes and nib pens and even droppers that come with some bottles. We'll also discover some inspiring and sparkling specialties.

Acrylic Inks

Acrylic ink is one of the most popular mediums because of its universal properties. Highly pigmented particles mixed with acrylic binder provide vibrancy and are resistant to fading. These inks adhere well to all sorts of papers, making it possible to work in various techniques, such as layering, washes, and collage, in combination with charcoal, paint, and even pastels. Acrylic inks have a longer working time than a medium such as acrylic paint, so there is no need to use any additives or retarders.

Acrylic Ink

Acrylic ink can be used on almost any oil-free surface after preparing it with an acrylic medium such as gesso or matte medium. Some inks have a bit of an oily or glossy surface when dry, depending on the brand, but the color remains bright. Acrylic inks can be opaque or transparent and can be applied with a brush, liner, nib pen, or an airbrush.

These inks are super lightfast. Lightfastness in colored inks is the resistance to fading when exposed to natural or artificial light. This process is caused by UV radiation. Generally, most dye-based inks are bright and transparent. You can affect an ink's lightfastness by increasing the thickness of the layer, and although the color will inevitably fade, some parts will remain. When you mix inks, the lightfastness of the weakest ink will define the properties of the whole mix. Varnishing an artwork will help protect it from UV light. There is no need for extra protection when using lightfast inks because they are resistant to fading, but it's a good idea to cover the finished piece with a final layer of water-based lacquer. This helps protect the artwork from dust and UV rays. Use a glossy lacquer if you want to intensify the dark colors and a matte or satin one to keep the inks light.

Shellac Inks

These inks are made with a natural shellac gum that provides brilliance and brightness under light. You can obtain a satin finish or a glossy finish with a thick application of ink. I use shellac ink for my professional work because I love the painterly feel. Inks can be both pigment- and dye-based, and they can be protected with a workable fixative, which increases their light stability.

Acrylic ink, shellac ink, and calligraphy and drawing inks can be beautifully combined in one artwork when working on heavy paper with a minimum of 200 gsm (see page 18).

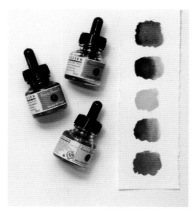

Shellac Ink

Shellac inks can be used undiluted, which provides maximum brilliance, or they can be diluted with water. They can also be diluted with a special shellac thinner to achieve a painterly and smooth feel.

Calligraphy and Drawing Inks

I still feel overwhelmed and excited when I see myriad colorful magic ink bottles in an art supply or stationery store.

Did you know you can easily paint with calligraphy ink? Calligraphy inks and drawing inks have a lot in common and can be applied in almost the same manner. Calligraphy ink is often pigment-based, is water-resistant, and can be used with dip and fountain pens. The pigments are fully lightfast, so the inks are designed to resist fading.

Drawing inks are dye-based, which means they'll fade over time. This property is something to consider if your artwork will be featured as a gallery piece or hung on a wall. Liquid dye-based inks are generally not waterproof when dry (except for India ink), so I don't recommend them for layering techniques.

Calligraphy Ink

Drawing Ink

Chinese and India Inks

These two inks are the most recognizable types worldwide. As you can guess from the names, these inks originated in China and India, but materials for both are often sourced in India. The most basic or classical form of these inks are ink sticks, which are rubbed on an inkstone and mixed with a little water to produce fluid ink. Small sets can be found in art supply or calligraphy stores.

Chinese ink is water-resistant and permanent and works well with mixed-media techniques. Some manufacturers add a small amount of varnish or shellac to make the ink lightfast.

TIP

If you plan to display your artwork at home or in a gallery, use lightfast ink. Most dye-based inks are extra brilliant but not lightfast, meaning some colors will fade or may fully disappear in a few decades.

You can affect an ink's lightfastness by increasing the thickness of the layer, and although the color will inevitably fade, some parts will remain. When you mix inks, the lightfastness of the weakest ink will define the properties of the whole mix. Varnishing an artwork will help protect it from UV light.

Alcohol Inks

This type of ink has become quite popular, and some artists even use it as their signature medium. Alcohol inks easily produce fantastic abstract effects with vivid colors on almost any surface, including fabric, ceramic, synthetic paper, stone paper, glass, clay, resin, and metal.

No drawing skills are needed when using alcohol inks to create abstract designs. Effects are achieved by adding isopropyl alcohol and using a heat gun to move the ink to create colorful splashes. Once the ink dries, it can be rewet, producing even more versatile effects. Different textures can appear when transparent layers are combined with opaque white and gold inks.

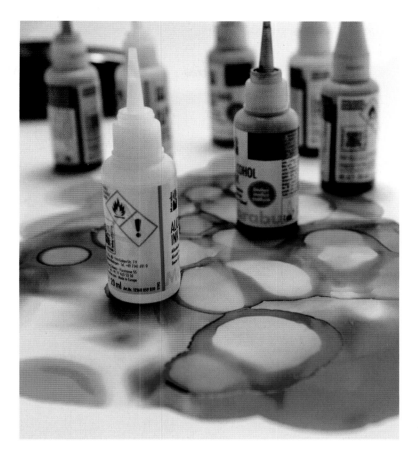

My favorite type of alcohol-based inks come in thin markers. These inks are mixed with alcohol and can create fantastic deep gradients and blending effects without using any water.

When working with alcohol-based inks, it's better to work in a well-ventilated area or outside. Otherwise, it makes sense to wear a mask/respirator to protect yourself from strong evaporating alcohol fumes. Alcohol inks in bottles are very messy, splashy, and extremely fast drying when alcohol evaporates. I recommend using gloves to protect your fingers and hands.

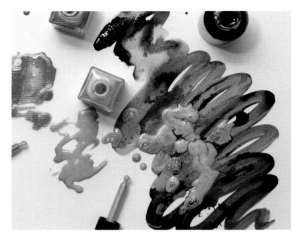

Metallic Inks

Metallics are the most enchanting form of colored inks. These inks consist of extra-fine metallic pigments diluted in a binder such as shellac or acrylic, providing remarkable consistency and properties. Unlike other colored inks, metallic inks have a higher viscosity and various levels of shine when dry. The ink coverage, brilliance, and drying time depend on the quality, so I recommend choosing a few professional-grade bottles. You won't need a lot, and they'll last a long time. Gold, silver, and white pearlescent shades show the most brilliance on dark papers and objects.

SPECIAL EFFECTS

You can achieve brilliance with inks through a number of effects, such as mixing pearlescent inks with basic hues. Shades can differ greatly depending on the tone of the paper or texture of the surface. Try adding a few shining drops of bronze ink to dark shimmering ink and see what happens.

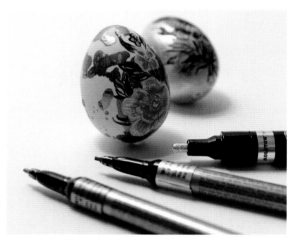

Metallic Markers

One of my favorite supplies is metallic effect markers. I use gold, bronze, and Liquid Chrome markers on various surfaces in my mixed-media projects. Liquid Chrome is a highly pigmented alcohol-based ink by Molotow that creates a stunning mirror effect. Similar effects can be achieved with bright silver markers.

These inks are opaque and work well for modern designs. I decorated these Easter eggs using just a few shades and added some interest with bold metallic elements. Such inks offer striking effects when applied to three-dimensional surfaces.

BRUSHES

Each brush has its own character. Brushes come in various shapes and sizes; the smallest is numbered with zeros (000) and goes up to 20 or 30, depending on the type of brush. Numbers 2, 3, and 6 are excellent for line drawings and inky paintings.

The good news is you don't have to buy expensive brushes when working with inks. Inks can be used with any type of brush or no brush at all. You can use natural hair and synthetic brushes with inks according to your preference. However, I don't recommend using natural brushes with acrylic inks because acryl can damage the hairs.

These are the brushes I use for most for my inky artwork. As you begin to work more with ink, try some of these brushes to see what they add to your artwork.

- **Synthetic round watercolor brushes in various sizes:** Usually three brushes, sizes 2, 3, and 6, are enough for almost any artwork.
- **A French brush, or mop brush:** This is specially constructed to hold a lot of water, and it allows you to make large and extra-fine brushstrokes. This brush is a favorite among many watercolor artists.
- **Chinese brush or Oriental brush:** This brush has a wide variety of sizes and holds water well.
- **Fan brush:** The shape is great for experimenting and for making unusual marks and textures. You'll use it for the flick and spatter effects in the basic techniques chapter (see page 23).
- **Flat wash brush:** Add this to your arsenal if you use a lot of water and want to create large washes. Flat brushes also vary in size, and some artists prefer painting straight lines with sizes 3 to 6, which are helpful for rendering architecture, bricks, and trees.

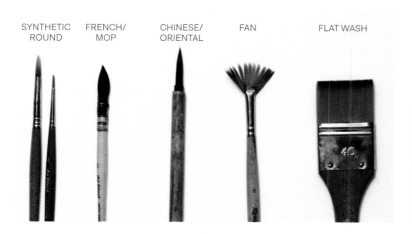

SYNTHETIC ROUND FRENCH/ MOP CHINESE/ ORIENTAL FAN FLAT WASH

TIP

Use separate brushes when working with acrylic or Chinese inks and clean them quickly after use.

PAPER

You may have seen papers made especially for ink in art supply stores. Myriad options exist. The optimal choice for inks used with pens and brushes is Bristol paper. This paper is smooth and allows you to move in any direction without damaging the pen or brush.

Although Bristol paper is a universal choice for any type of colored inks, every creative has a paper preference depending on their style and artistic goals. A vellum Bristol paper is less absorbent than watercolor paper but still holds enough water to add a few washes. This paper works great for pen and ink illustration, but it will wrinkle if you add a lot of water or use several layers of washes.

Your paper choice should be determined by the style and number of layers you plan to include in your work. Sometimes I work spontaneously and sometimes I scrupulously plan the painting up front, so I've been experimenting to find the ideal multipurpose paper that allows me to work in any style.

I've found that acid-free watercolor paper works best for me for colored inks. Watercolor paper comes in various weights and textures, but for ink you should use a paper with a weight of at least 250 gsm (grams per square meter) so it can hold enough water to create washes. Here are the pros and cons of the three types of watercolor paper:

- **Rough:** This paper has a lot of texture and tooth (surface feel) and works great for landscapes and abstract art. However, it's not suitable for extra-fine nib pens because the nib catches on the surface, damaging both the paper and the tip.
- **Hot press:** This has the smoothest surface and will show tiny details and fine lines. The paper can also hold a lot of water but is less forgiving. It's much harder to make changes such as adding multiple layers or lifting off inks because the surface has no tooth.
- **Cold press:** This paper, with its slightly rough finish, is my favorite. It can be used to create details and expressive lines. Cold-press paper is ideal if you plan to layer color over fine lines.

TIP

Eraser marks are noticeable on Bristol paper, so it's better to plan what you're going to paint, or you can work with opaque inks that will cover the marks.

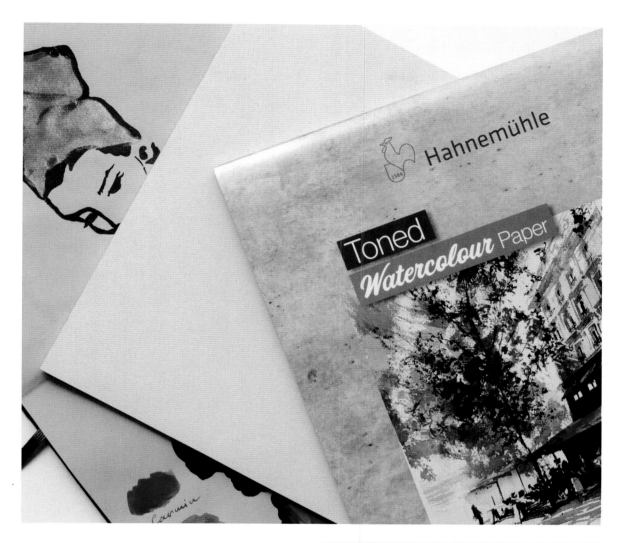

Toned and Black Paper

I remember how fascinated I was the first time I painted on gray and tan-toned watercolor paper. You can add a three-dimensional feel to any subject with just a few strokes. Since the paper provides the middle tone, you only need to add lighter and darker tones. The gray tone works well for moody, cold winter scenes, and the warm tan is great for portraits. You can also create enchanting starlight effects by applying white ink on black paper.

TIP

The higher the gsm number, the heavier the paper. I prefer working with 300 gsm, and for some gallery pieces I'll use 600 gsm paper. The gsm number can usually be found on the cover of the pad or block, near the size and surface type.

Sketchbooks

Before starting any sketching journey, I always think about two things: Where should I sketch, and what should I sketch? I choose a particular sketchbook based on my answers.

So many types of sketchbooks are available that choosing one can be overwhelming. These are my favorites for colored inks.

- **A large hardcover notebook with a cased-in binding:** The pages are sewn together in sections, but the book lies flat and is very comfortable.
- **Softcover sketchbook with a saddle stitch (stapled) binding:** This type of sketchbook usually has a small number of pages and might have short-term use. I use it to test brushes or collect color palettes and exercises.

- **Spiral notebook:** This style is extremely low-cost, so you can have a useful, affordable sketchbook to carry around.

Toned watercolor sketchbooks are perfect for creating illuminated letters and other effects. I use them in the studio for thoughtful, detailed projects.

These are the most conventional types of sketchbooks. You can find varieties that look like ancient treasures, grimoires, or enchanted, illuminated manuscripts. I also love custom-made treasures.

Brush Pens

A brush pen (sometimes called a fudepen) is a drawing and writing tool that consists of a brushlike nib fed by an ink reservoir. The nib can look like an ink brush or may have a felt marker tip. Brush pens are becoming more popular these days for painting as well as calligraphy and different lettering techniques. Not surprisingly, a wide variety of options are available.

A few things should be considered when choosing a brush pen: ink flow, the versatility of the tip, and the tip's size. These choices are personal, and you can try tester pens in art supply stores to find out which option you prefer.

Using brush pens on Bristol paper allows you to create fine lines and add a layer of watercolor on top of the ink. Good-quality brush pens provide a variety of thick and thin strokes, and synthetic tips boost creative freedom. Press hard on the tip to get a wide stroke and lift the brush to get delicate lines. Gently squeezing the plastic reservoir results in a heavier flow, depending on the pen's design. Some brush pens have empty wells that can be filled with a unique color mix.

I'm a huge fan of extra-fine artist Japanese brush pens. The brush nib feels almost like a real paintbrush, with an extra-long brushlike tip that creates the finest lines. The pen uses replaceable colored ink cartridges, making it an excellent option for working in a sketchbook or drawing on the go. My favorites are Pentel Arts Pocket Brush Pen and Sign Pen.

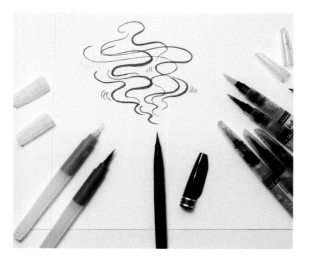

Some types of brush pens come filled with colored inks, and they can be used almost like watercolors. Other types have empty wells that can be filled with your desired colored ink and applied with a fine synthetic tip.

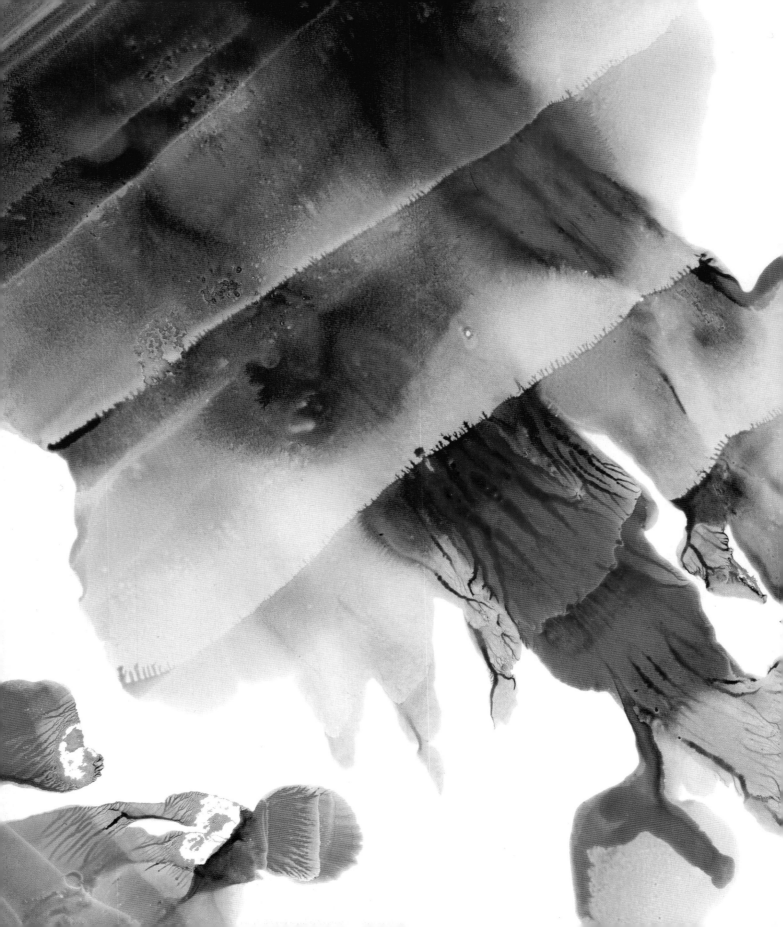

2

BASIC TECHNIQUES
AND BEYOND

- - - - - -

Starting a new piece of artwork can seem overwhelming at first, but by making tiny steps and exploring possibilities, you'll turn the process into pure joy. Let's explore some wonderful techniques that you can apply to your artistic practice.

In this chapter, I'll introduce you to several techniques with ink, including my favorite: creating monotypes. This simple and satisfying method boosts your imagination and creativity. With this fine art practice, you can create a unique artwork in minutes!

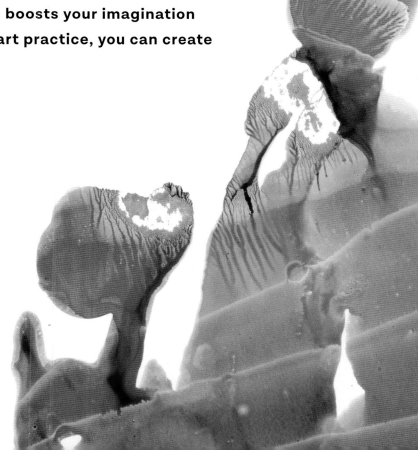

MARK-MAKING WARM-UPS

This is a great warm-up exercise for practicing mark-making skills with colored inks, and it incorporates both brushes and nib pens. You can use any type of colored inks, but it's best to work on watercolor or Bristol paper that can hold enough water.

Work on a standard sheet of Bristol or smooth watercolor paper (I'm using 8.3" × 11.7" [21 × 30 cm]). Fill the entire page with various experimental marks using a nib pen. Don't overthink what marks you want to make—just try! Hold the pen in a way that's comfortable and try making straight, short, curvy, messy lines and strokes. The amount of space between the strokes determines the lightness or darkness of the pattern. Mix sharp-pointed open strokes with sweeping swirls. Begin drawing with the nib pen at one angle, then change the speed and vary the depth by pushing it harder onto the paper. Try a free-flowing ink stroke, then roll it into an oval shape.

Notice that some of your lines create visual texture and value, while others only suggest two-dimensional graphic effects. Imagine drawing a tree with just a few marks like this. Try working with the pen as if you were going to ink the crown of the tree, changing the position of the marks.

With a simple line, you can create an illusion of depth and move the viewer's eye in any direction. Change the angle and direction of the strokes, and the eye will follow. Imagine a three-dimensional object in your head and try to "wrap" it with marks to describe its shape. You can draw a light pencil sketch of a shape first, cover it with marks, and then delete the rest of the graphite when the ink is completely dry. If you draw cross-hatched lines, make sure the first set of lines is dry before creating another set so you don't smudge the ink.

Nib pens are diverse, so you can achieve an incredible number of effects with them. They're pretty inexpensive, so you can try a lot of pens to find the ones you love. Nibs and holders are sold separately; holders are typically made of wood or metal.

Nibs vary in sizes and styles. Some are flexible, while others are stiff. I prefer the ones with a very fine tip—the word "fine" refers to the size of the tip and not the quality.

A **fountain pen** is a nib pen that contains an internal reservoir of liquid inks. I love drawing with these pens, but even the best ones don't have the versatility of lines like a classic nib pen does.

Here, I've make a variety of marks with a nib pen.

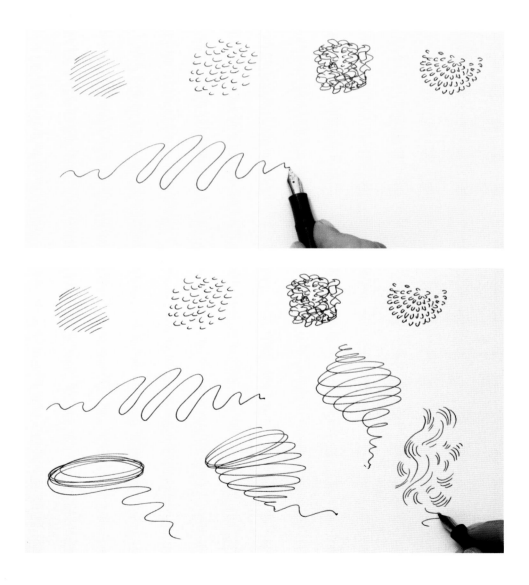

Exercise: Dancing Brush Warm-Up

1 If you prefer working with a brush (like I do), I'm sure you'll love the exercise I call the dancing brush. Before you begin, fill a page of Bristol or smooth watercolor paper of any size with simple brush-strokes that resemble the letter *S*.

2 Load a small synthetic brush with ink. Lightly touch the paper with the tip of the brush, press the brush flat onto the paper, then lift it so only the tip is touching again.

The width of the brush creates the curve, making a beautiful variety of stroke widths. Use your brush to give the lines character.

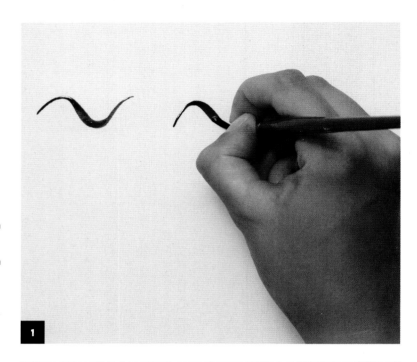

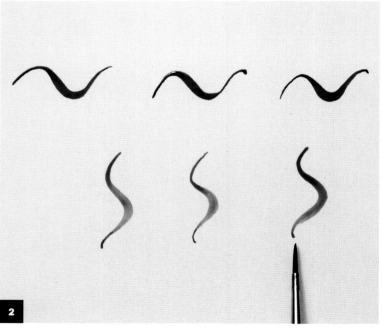

COLOR

Color theory, color wheel—I'm sure you've heard these terms before. If you're like a lot of creatives, you may still feel challenged when putting the concepts into practice when creating artwork. I know the feeling! Not to worry. I'll provide a brief overview with some practical tips and ideas I believe are the most essential when working with vibrant colored inks.

Color Value

Value is a fundamental characteristic of color. Color value refers to the lightness and the darkness of a color.

These properties can be changed by adding white or black to any hue. Add black to any color to make a darker shade. Add white to make a variety of lighter tints from any color or mix.

You can use a full value range in one artwork or focus only on high-key choices by choosing light colors. For dramatic and moody effects, include plenty of dark areas, creating a low-key image.

To simplify the process, limit the range to three values: low, middle, and high key. When creating an artwork, think about these value relations and which parts of the image will be the lightest and the darkest. Even if you use just one color and apply a full value range with it (called monochromatic), the artwork will look interesting and intense.

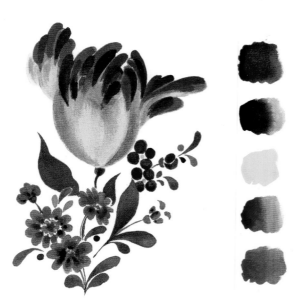

Color is a personal choice. Look at your wardrobe, the covers of your notebooks, and the fabrics, jewelry, phone cases, bikes, and even food that you choose. Trends change every season, and that may influence our choices. You can spot these trends in the design and fashion worlds and the annual Pantone Color of the Year.

Although it's fun to experiment, I encourage you to be true to yourself and master the endless varieties of palettes that please your soul.

Meet our old friend, the painter's wheel, or color wheel. Most color wheels feature twelve colors, but endless iterations exist. Here are a few things to note:

- **Primary colors** are red, yellow, and blue. They're referred to as primaries because you can't create them from other colors. The word *primary* may be added to paint or ink names to denote that this is the most vivid hue, such as primary cyan.
- **Secondary colors** are created by mixing two primary colors. For example, mixing red and blue creates purple.
- **Tertiary colors** are created by mixing a secondary color with a primary one. Mixing purple with primary blue results in blue-violet.

I didn't pay much attention to these concepts for a long time. Most valuable for me was the feeling of a color and the emotion, impression, mood, and temperature it created. That's still the case, to be honest.

Primary colors

Black and white create the strongest contrast of light and dark. Similarly, placing red, yellow, and blue together makes the most powerful color contrasts. When colors are placed near white, it makes them appear lighter. Placing colors near black causes them to look brighter.

PROPORTIONS OF COLORED INK

- - -

All of the hues in the color wheel are available to us, but as intelligent artists, we never apply all of them in one piece of work. If you use similarly bright colors in equal amounts in a piece, their effect will fade.

I created this artwork for Heinrich Heine's lyric poetry book and aimed for a moody, atmospheric feel with brighter accents. The earthy, calming, inky color palette is contrasted with small dots of vivid turquoise and warm yellow.

Pay special attention to these elements of color theory so you can be playful and creative with the subtleties:

- **Complementary colors:** These are the opposite colors on the color wheel. These pairs make each other bright and vivid when painted near each other but turn into gray-brown neutrals when mixed. The most common pairs are red and green, yellow and purple, and blue and orange. You often see these complementary combinations in eye-catching design posters or packaging, including warning signs.

- **Analogous colors:** Use a few colors that are close to each other on the color wheel to create harmonious and sophisticated artwork. For example, use colors that make a smooth transition from yellow to red-purple.

Complementary colors

Analogous colors

Advancing and Receding Hues

Use the principle of aerial or atmospheric perspective to add the illusion of depth to your artwork. Warm colors such as yellow, red, and orange appear brighter and nearer to the viewer, while cooler hues such as blue and green appear farther away.

If you imagine a hazy mountain landscape, the mountains become lighter and cooler in tone as they recede. This principle works for any subject matter.

Exercise: Optical Color Mixing

Colored inks can be extra vibrant. Since every brand is different, it's a good idea to do some test mixes up front. These steps outline my favorite color-mixing method.

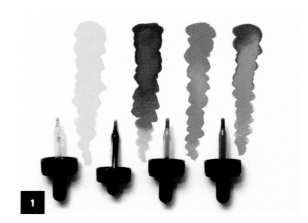

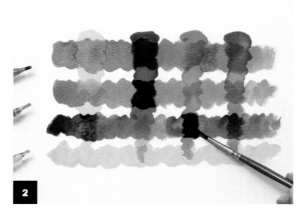

1 After choosing a color palette for a painting, place all the colors in rows and allow them to dry.

2 Place the same colors vertically on top of the first row, creating a reference chart. Be sure to leave white space around the edges when inking so the colors don't run into each other. This chart allows you to see how the vivid inks interact, such as the green shade when yellow is painted over blue.

3 Take note of the combinations to avoid. Some color mixes are called muddy, usually referring to browns, grays, and green tints. I believe there are no bad or wrong colors, but optical color mixing allows you to see which colors don't suit a particular work.

Setting a Color Palette

Working with a limited color palette is best for beginning artists to avoid becoming overwhelmed with choices and to better focus on the creative process. I suggest choosing primary colors and a few additional hues that you love. You can add variations to achieve desired effects.

Some artists prefer establishing a palette of colors, and some like to work intuitively, adding colors according to the feel and flow of the process. Try both options to discover what suits you best.

Preparing a color palette up front is a great way to unify artwork and create a balanced look. This can be done in several ways. For example, you can add a small amount of one color, such as yellow or gray, to all the mixes you're using. Or, you can set a palette with particular colors and be consistent throughout the artwork.

Here are some suggestions for choosing colors for a palette:

- Get inspired by the artworks of your favorite artists, movies, and even books, and pay attention to the colors they're using.
- Have an inspiration folder where you collect ephemera and other pieces, or use Pinterest.
- Pay attention to the things around you that you love, such as books, music, and plants—even fabric and clothing.
- The most important thing is to listen to your inner voice and not force yourself to paint loose pink flowers if you're drawn to dramatic rainy landscapes.

Color palettes can create a variety of moods, and you can use them to convey emotions. A strong, cheerful feel can be achieved with yellows, reds, and magentas. Conversely, artwork that is melancholy or sentimental needs cool grays and blues.

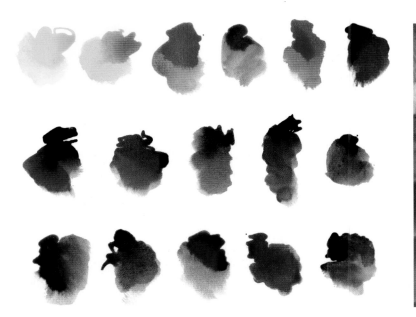

TIP

Add a bit of white to any ink color and mix thoroughly to make a pastel hue. Using this mix, you can create a soothing lavender color from violet or fresh mint from green.

USING COLOR

- - -

There are two main ways of using color: naturalistic and imaginative. The first approach is inspired by nature and uses color to create an illusion of reality. The second is based on imagination and can include extra-vivid colors or unusual color combinations that don't exist in the natural world. Acrylic inks work well for this style.

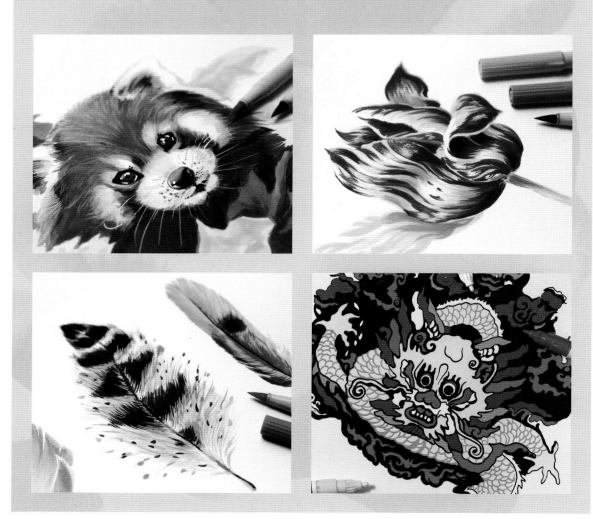

WASHES AND GRADIENTS

If you want to cover large areas of your artwork, washes and gradients are the most effective techniques. Both look impressive, reproduce well in fine prints and on the web, and bring a moody or cheerful atmosphere to any painting.

Let's discover the unique properties and limitations of these water-based artistic methods.

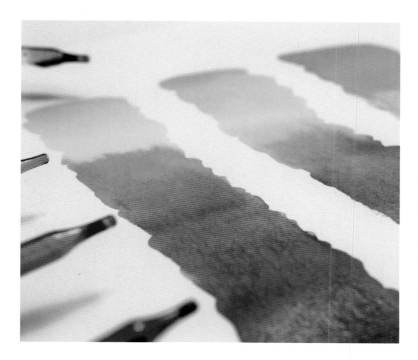

Ink Washes

A wash is a mixture of pigment (in this case, ink) and water. The lightness and darkness of the wash are controlled by the amount of water mixed with the pigment. You can also control the value by layering a wash over white paper, over a dry layer of wash, or over any background. The intensity can increase by repeating layers several times, but keep in mind that only one or two colors are usually used for an effective wash mix. Make sure the first layer of wash is completely dry before adding a new one.

A flat wash is a basic technique used to cover a large area using a big brush. A graded wash is a smooth blending of color from light to dark and vice versa.

TIP

The paper you use for creating washes is crucial, because a wash incorporates a lot of water. Heavy watercolor paper (300 gsm) of your choice (rough, cold press, or hot press) won't buckle. Secure the paper sheet on a board with paper tape or work in a watercolor block.

Keep these essential properties of washes in mind as you work.

- A wash can provide a full range of values, starting with the lightest shades and ending with a dark, solid color. This allows you to create a variety of desirable effects, such as fluid, light, watercolor-like washes or darker, moody, atmospheric inky scenes. You can add a wash or layers of washes at any stage of a piece. When completely dry, you can add fine lines or expressive brushstrokes.
- The technique is unpredictable. The liquid nature of the wash makes it difficult to control, but at the same time provides a fantastic variety of effects.
- Washes work well for creating skies, water, or moody backgrounds.
- Washes generally dry quickly but can vary depending on how much water is used, the type of paper, and weather conditions. They're handy when you need to quickly create a large background or tonal painting, but be aware of some pitfalls. If you didn't create enough wash to cover an area and need to mix more, you may get unwanted streaks or bleeding between the tones. If you use a small brush, it may transfer tiny pigment particles to the paper and make streaks or marks. But we know there are no mistakes—only happy accidents!

Exercise: Create an Ink Wash

To master this adventurous technique, you'll need watercolor paper (see Tip, page 33), any kind of ink, a lot of clean water, and a palette or small plate (dedicated for ink) to mix the ink. I used a large bottle of pigmented waterproof caput mortuum ink (a deep purplish-brown shade) and my usual brushes.

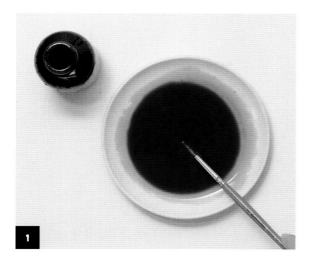

1 Pour some water onto the plate or palette, add a lot of ink, and mix it thoroughly. The ratio of water to ink depends on the intensity of the wash you want to make. Make sure you have more of the watered-down ink than you plan to use.

2 Place an object under the drawing board or paper pad, such as a tape roll or something similar, so the board can tilt a little. This slight angle allows you to guide the wash gradually.

3 Choose a brush that's compatible with the size of paper you're working with. For a wash, pick a brush that holds enough water. If it's a synthetic brush, use size 6 and up; if it's a mop brush, even size 1 can be enough.

 Load the brush with the ink wash. Apply a puddle of ink at the top of the paper and glide the brush down, using back-and-forth motions. The highly granulated pigment-based ink I'm using creates wonderful texture right away.

4 Always start a wash with a puddle of ink, and add as much wash as you need along the way. Continue the wash by keeping the puddle large as you go. When the area is covered, remove the final puddle with a dry brush, soaking up the excess ink.

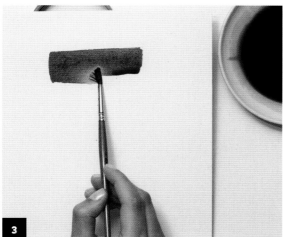

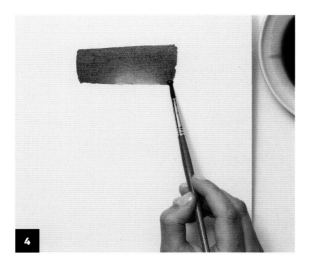

TIP
Never work back into a finished area while it's still wet; this will result in unwanted streaks and bleeding between the tones.

Gradients

By adding increasing amounts of clean water to an ink puddle, you can lighten the tone and create a beautiful fading effect, called a gradient. It works the opposite way as well; by increasing the amount of ink, you can intensify and darken the value.

Exercise: One-Color Gradient

A gradient can be used as an atmospheric background or a stand-alone effect.

1 For this technique, you can use any type of colored inks and Bristol or watercolor paper. If the ink is concentrated, dilute it in water, aiming for a 1:1 mixture.

2 Begin painting a strip (I used bright orange) with a synthetic round brush, size 6 or larger. I chose this color because it reminds me of gorgeous sunsets.

3 Clean the brush and, with a wet brush tip full of clean water (no ink), continue painting where you left off.

4 Continue working with water, creating a smooth transition between the ink and the water, until the end of the strip becomes fully transparent. Be mindful of the amount of ink you're putting in the water as you work. You're aiming for a smooth transition.

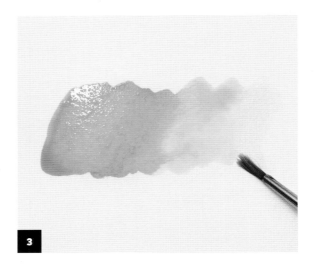

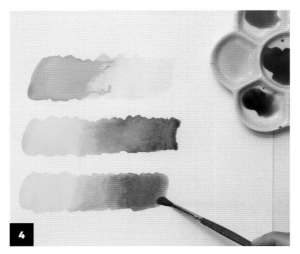

You can also use multiple colors to make a gradient, where one color seamlessly blends into another. Create a few color strips using the following techniques to discover the combinations you like most.

Exercise: Multicolor Gradient

Let's explore how to create a multicolor gradient by painting a water lily leaf (Nymphaeaceae) inspired by vintage Japanese woodblock prints.

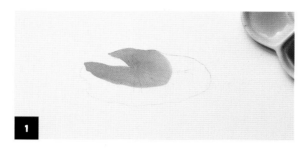

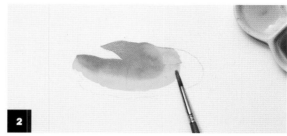

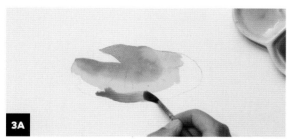

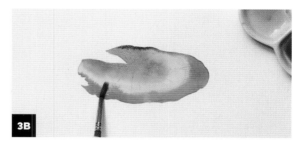

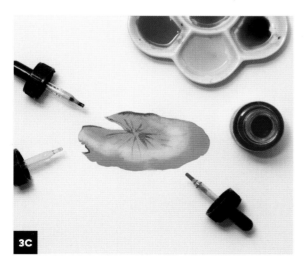

1 Add some green, yellow, and carmine red inks (any type of ink will work) to the wells of a palette. Draw a water lily leaf lightly on watercolor paper with a pencil. Add a light layer of green ink to the centermost part of the leaf. I used shellac inks and a size 6 synthetic round brush.

2 While the ink is still wet, add a yellow border around the green area. You'll notice how the edges blend on the paper right away.

3 While the inks are still damp, add the third layer of carmine red around the yellow area, to the edge of the leaf **(3A, 3B)**. The beautiful gradient is complete. Add a few lines of carmine to define the veins of the leaf while the gradient is still slightly damp **(3C)**. Working on a wet surface blends the lines, resulting in a beautiful effect of blurry edges and creating natural transitions you couldn't make intentionally.

WET-ON-WET

Wet-on-wet is a technique of applying a layer of wet ink (or paint) to wet paper. This method requires working quickly, because the desirable effects of merging or blending colors should be achieved before both layers are dry.

This basic technique is also known as indefinite blending or alla prima. With just a few elementary steps you can create a variety of effects and unexpected textures with intense colored inks. This technique works especially well for creating abstract paintings, backgrounds, skies, surface pattern designs, and clouds. It's helpful for beginners and allows you to become more familiar with your ink.

Some inks will blur and blend naturally while others will dominate. For example, if you mix earthy tones such as burnt sienna or Indian red with crimson or blue, the highly pigmented browns will spread more and fill more space. Keep in mind that colors will lighten a bit when dry, even when using highly pigmented ink.

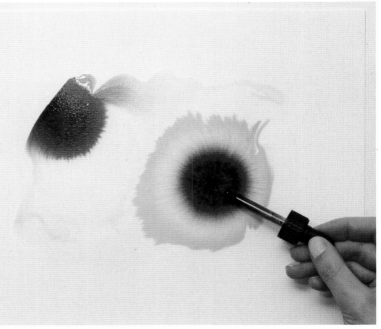

TRANSPARENT AND TRANSLUCENT EFFECTS

Colored ink is a thin medium. When diluted with water, it becomes more transparent, and the intensity of the value changes. This is also referred to as opacity. Even opaque inks can be diluted to become semitransparent, allowing a previous layer to shine through. Let's see how this works with an exercise that uses cobalt blue ink.

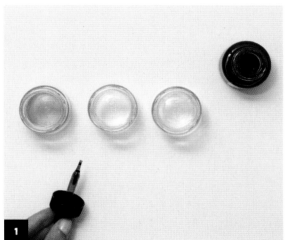

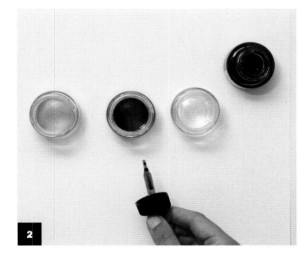

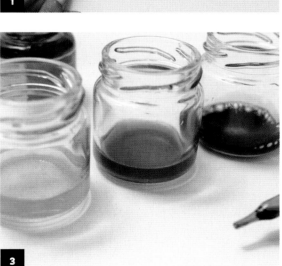

Exercise: Explore Tones

1 Prepare three small jars or three deep palette wells by filling the first two with water. Add one drop of cobalt blue drawing ink (or any color of your choice) to the first jar or well. This creates a lovely light color and is your first tone.

2 Add two or three drops of ink to the next jar. You can see the difference in an instant. The tone increases, but the color is still very transparent.

3 Fill the last jar with ink straight from the bottle. This is the darkest tone.

(continued)

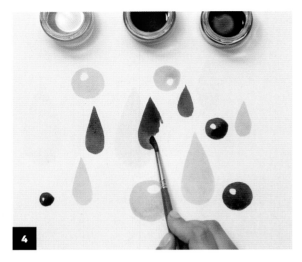

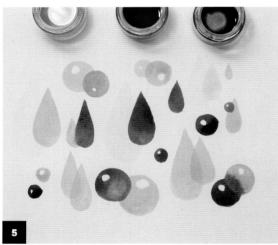

Experiment with layering vividly colored transparent inks. This is a great way to learn which colors you like and discover unusual combinations.

1 Paint a few brightly colored blobs. Allow the ink to dry.

2 Paint more shapes over the first layer using diluted lemon yellow transparent ink. Notice how the glaze of color changes your perception of color. Think of this as looking through colored glasses that transform the objects you're looking at.

4 Paint a raindrop shape on watercolor or Bristol paper using the lightest tone and a large size 6 round brush. Add more raindrops of various shapes and sizes with the same mix. Repeat, painting more shapes using a second darker tone. Allow the ink to dry. Add more drops with the third, darkest tone.

5 Paint more raindrops that overlap the first layers with any tones. You can see how the intensity increases when the shapes overlap.

THE POWER OF SILHOUETTES

Creating a powerful silhouette is arguably one of the most precious skills an artist can possess. When the core characteristics of a subject are expressed correctly in a silhouette, the artwork becomes convincing regardless of the style.

Lesson: Cat Silhouettes

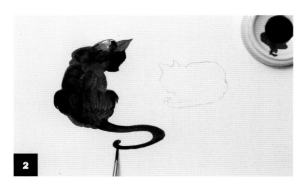

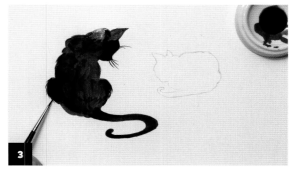

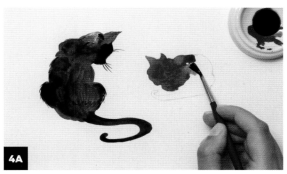

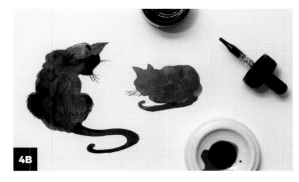

1 Using the template (see page 122) or another reference image or your own imagination, draw a couple of basic outlines of cats that define their shapes and edges. Use light pencil lines on watercolor paper.

2 Begin inking one of the silhouettes, starting with the top left corner of the head. I used dark violet shellac ink and a size 3 round synthetic brush, but you can use any color and any type of ink. Use inks straight from the bottle, since the goal is not to create a perfect wash. I worked in a grungy manner, using a variety of brushstrokes. For a more idyllic silhouette, use a wash technique to color the subject (see page 33). This method works for large and small areas, regardless of details.

3 Add tiny details with a small round brush, such as whiskers and a few tufts of fur. As you paint, keep in mind the direction of the fur. This makes even a simple drawing convincing.

4A, 4B Ink the second cat using a lighter ink tone that conveys it's in the distance. Your purrfect company is ready!

NEGATIVE PAINTING

Have you heard of Rubin's vase? Even if you're not familiar with the name, you've no doubt seen this silhouetted image of two faces that form a vase in the negative space.

Negative space, or air space, is the area between and around objects. Instead of drawing a vase, you could draw the space around it and the vase will appear. Usually, negative space is defined by the white of the page, while the rest of the space is drawn or painted.

As with a silhouette, this technique helps achieve maximum effect with minimal effort. You can create this effect by painting directly on the surface or by using masking fluid or masking tape to cover areas.

Exercise: Negative Space Swan

For this exercise, I was inspired by Hans Christian Andersen's fairy tale *The Ugly Duckling*, and I created three similar sketches of the swan.

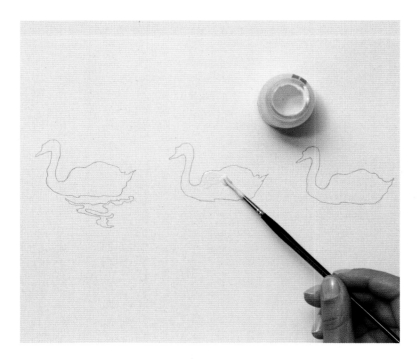

1 Draw three swan outlines using light pencil lines on watercolor paper. Cover the entire swan with masking fluid using an old brush. Allow the masking fluid to dry (this may take some time).

 Note: Masking fluid is available as a liquid in a small bottle or in a pen. This rubberlike medium blocks out and protects small areas from paint.

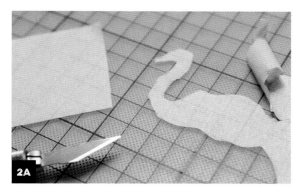

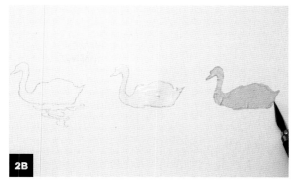

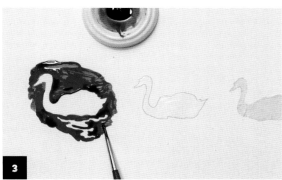

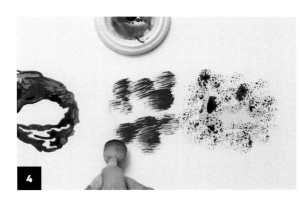

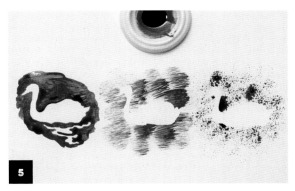

2 As the fluid dries, cut the shape of another swan out of a large piece of low-tack tape **(2A)**. If you have narrow tape, adhere a few strips together to create a larger piece. Place it carefully on the corresponding swan **(2B)**.

3 For the first swan, use violet drawing or shellac ink (or any bold color) to paint around the sketch to define its shape. The beautiful swan is glowing! Draw some ripple shapes and paint around those as well, adding interest and dimension to the artwork.

4 For the second and third swans, use an inked sponge or just a brush and make some strokes directly on and around the birds. I love the texture created with a sponge; you can tap it or even slide a bit on the paper to create a variety of effects. Allow the ink to dry.

5 Remove the masking fluid by gently rubbing it with your fingers, and carefully remove the masking tape. You have a negative painting of beautiful swans.

DRIBBLE, SPATTER, FLICK

Try dribbling, spattering, and flicking inks if you want to experiment and add unique textures to your artwork. Every combination of ink, paper, and application is different, so don't be afraid to try it many times. And then come back and try again. The results can be rewarding!

Dribble

Add a few drops of ink in select areas on dry artwork and let it dribble. Hold the artwork vertically as you dribble the ink. This effect looks amazing on fashion illustrations.

Perfectionists may be terrified by runaway ink but try to be open to experiments and see it as another creative opportunity.

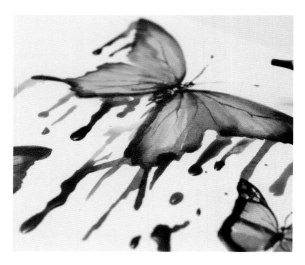

Spatter

Prepare the ink (any type will work) by diluting it with a small amount of water in a palette as you did for the wash technique. Load a synthetic pointed brush with the ink wash. Chinese and mop brushes will also work well for this technique because they hold a lot of water.

Use your hand to snap the brush against the paper. You'll see a lot of tiny ink spots across the paper.

I used light olive green and a bit of warm yellow with a small round brush for the spatter technique on this painting of a buckthorn, which reminds me of summer. If a painting is missing something dynamic, adding texture this way is a great idea.

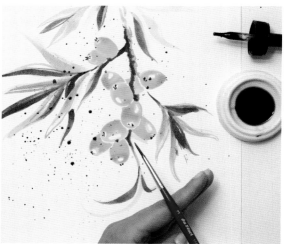

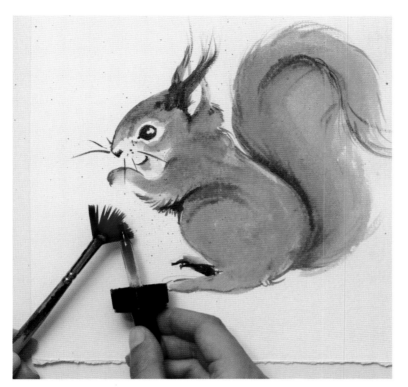

Flick

We need more unpredictable textures, so we'll add those by flicking ink.

Load a fan brush or any flat brush with ink. Flick an ink dropper or your finger across the brush to create a spray of spots.

If you want to add this technique to a particular artwork, try the technique first on a separate sheet of paper. It may be more unpredictable than you think.

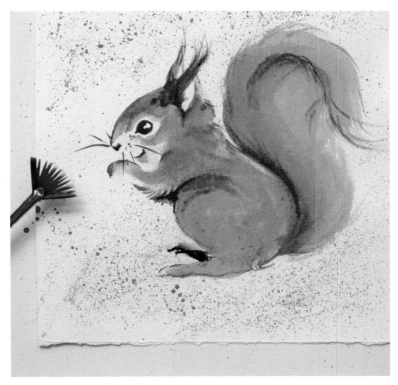

TIP

Be sure to cover your work surface with a protective cloth or newspaper before spattering, especially if your studio is your worktable in the bedroom with a laptop and collectible porcelain figurines nearby!

INK DROPPERS

An eyedropper or ink dropper has an intriguing charm and long history. Also known as a Pasteur pipette, this tool is used to transfer small quantities of liquids, which is what we'll do with inks. The most common ink pipette is a glass tube with a rubber bulb at the top, which often serves as the cap on a bottle of ink.

Ink droppers are useful for the following:

- Adding vivid color directly onto artwork without using a palette
- Working wet-on-wet (see page 38) and dropping ink straight from the bottle in an abstract manner
- Working with a potentially hazardous liquid (such as bleach or alcohol) without exposing it to the environment
- Adding tiny details to flowers or patterns
- Creating glazing effects (see page 58) for eyes and shiny objects

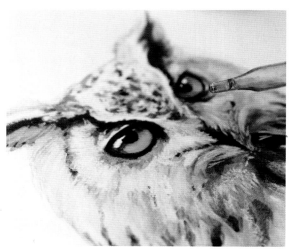

TIP

Lemon or warm yellow colors work wonderfully with the glazing technique using an ink dropper to add luminous effects.

MONOTYPES

Sharing my favorite fine art technique with my fellow artists is pure joy, and I've been waiting impatiently for you to discover the monotype technique. Monotypes are a hybrid of drawing and printmaking and offer endless possibilities. Artwork is created by painting or drawing on a smooth, non-absorbent surface. Previously, this was done on a copper etching plate, but modern artists can use glass. A monotype print is made by pressing a plate to paper, resulting in a one-of-a-kind piece of art. This technique is usually done without an initial sketch. Most of the ink is removed during the first pressing, with some ink left on the glass. More prints can be made from the remaining ink, but these pieces differ greatly from the first print and are not considered originals.

For this exercise you'll need a piece of glass—I took one from an inexpensive A4-size picture frame (about 8½" × 11" [21.5 × 28 cm]; cover the edges with tape if they're sharp—paper, size 3 and 6 synthetic brushes, and shellac ink (I used indigo, violet, and purple).

The most important component is paper. To create beautiful fractals, use synthetic chalk-coated paper such as Yupo, stone paper, or glossy-coated paper, which is often used for calendars and magazines. Glossy-coated paper doesn't absorb ink into the paper fibers, creating the beautiful fractal effects we're looking for in the monotype technique. You can also work with Bristol paper.

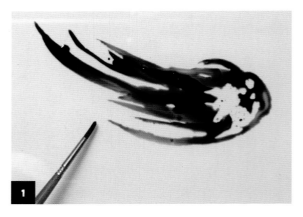

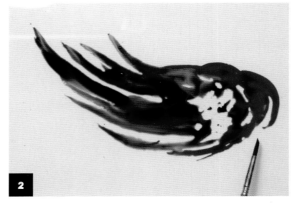

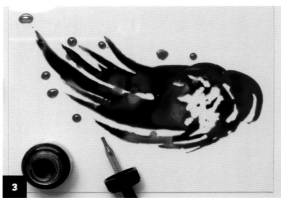

Exercise: Monotype Gradations

1 Paint a loose silhouette of a jellyfish with indigo ink directly on the glass, using large brushstrokes.

2 Brush on a bit of violet with a smaller brush to create a beautiful gradient.

3 Add a few drops of a vivid contrasting color from an eyedropper to add accents.

4 Place a sheet of paper on top of the glass while the ink is still wet and remove it immediately, peeling it off gradually. Slow, steady movements create particularly beautiful gradations of texture. Discover what magic has happened!

5 If ink is left on the glass after pulling a print, try again. Add a few drops of inks and repeat the process.

This captivating technique develops your imagination and gives you a truly unique experience. Children's book illustrators often use monotypes for backgrounds or stand-alone artworks. Experiment with a variety of color combinations to unlock your creativity.

TIP

If the glass repels the ink, wash it with soap and water. Don't be discouraged if your first attempts at creating a mono-type look weird—it can take a few tries to find the ideal pace and combination of ink and paper. You'll be amazed by what you can create with this technique.

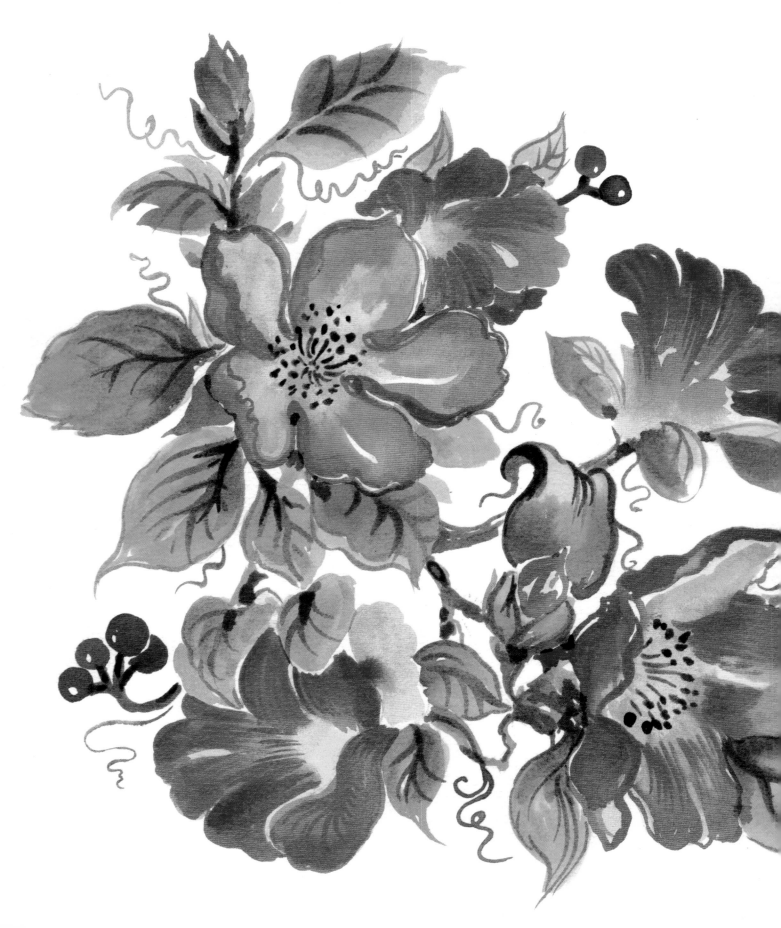

3

FLORALS AND NATURE

- - - - - -

If you're inspired by nature and can gaze at painterly scenery for hours, you'll love the lessons in this chapter. The variety of florals and plants can be expressed in endless ways with ink. Whether you're painting the mythological Flora and Freya, scientific botanical gardens, or enchanted forests, your individual vision is what makes an artwork unique. I can hear the shivering leaves calling. Let's move on!

LESSON: MUSHROOMS

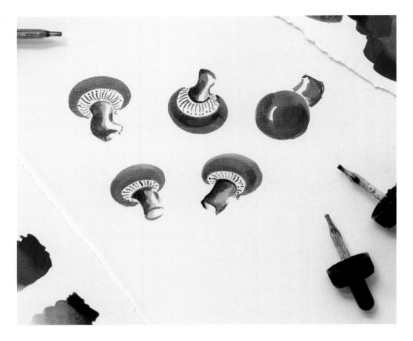

MATERIALS

- - -

Watercolor paper: cold press, 100% cotton, 300 gsm

Drawing inks: purple, carmine red, and deep green

Brushes: synthetic round, sizes 3 and 6

Fungi, puffballs, amanita—these fairy-tale life forms can fuel your imagination in an instant.

Historically connected to witchcraft, fungi can add vibrant, bizarre, and intricate elements to any scene. Painting mushrooms with ink can be a lot of fun. Once you master the basic shapes, you'll be able to turn them into an endless variety of eye-catching toadstools.

1 Prepare the color of the mushroom cap. I mixed purple (this color is closer to a bright pink) and carmine red in a 1:1 ratio to add interest. Even the subtle variety of hues can make a huge difference when painting a simple object.

2 Choose the color for the stipe, or stalk. Depending on how much of a contrast you want between the cap and the stipe, you can use subtle gray, vivid yellow, or muted violet. This is a good time to review the information on working with a color palette (see page 31). I chose green, a complementary color to the cap, and I mixed it with purple to create a neutral greenish-violet that will be perfect for the stipe.

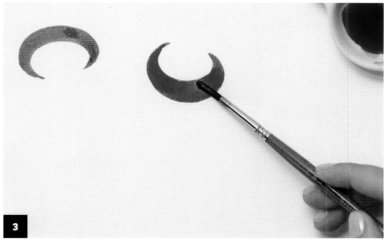

3 Dab the size 6 round brush into the red/purple ink mix and paint a half ellipse. Begin painting with the tip of the brush to create a thin stroke, push the brush onto the paper to get a thicker stroke, and then lift the brush to create another thin stroke. Make sure the points are rounded; the viewer's imagination will complete the shape. This shape can be easily created with brush pens too (see page 21).

4 Repeat painting the caps in semi-ellipses, experimenting with direction and angle. Imagine painting the letter *C* or a crescent. Create an imperfect circle for a side view of the cap as well. Use different hues and discover beautiful color combinations.

(continued)

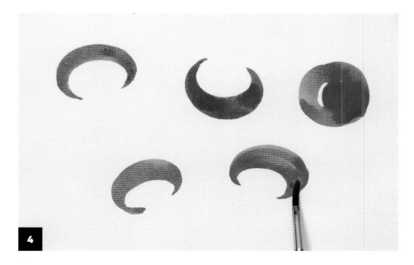

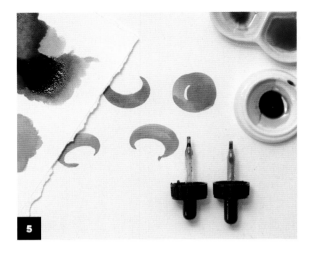

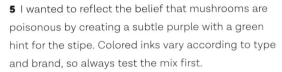

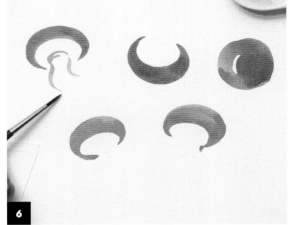

5 I wanted to reflect the belief that mushrooms are poisonous by creating a subtle purple with a green hint for the stipe. Colored inks vary according to type and brand, so always test the mix first.

I used a tiny porcelain palette to control the proportion of the inks. Shellac inks are a bit thick, so add a small amount of water to the mix to dilute the inks a bit.

6 Paint some lines defining but not completing the stipe outline using this color mix and the size 3 round brush. Be sure to leave some of the white paper showing.

7 Add a subtle layer of the same green-purple mix on the stipe using the flat side of the size 6 round brush. Instead of coloring the full shape, use the lost-and-found line technique (see Tip at right).

To continue working on your piece while other parts continue to dry, place a small sheet of paper under your drawing hand to protect the artwork from accidentally smudging.

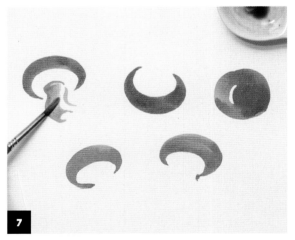

TIP

Try using what's called a lost-and-found line in your work. The painted line of the stipe indicates the hard edge of the subject, but the outline isn't complete. The missing part of the line suggests that the edge is soft or that you can't see it. This makes even simple images look more interesting.

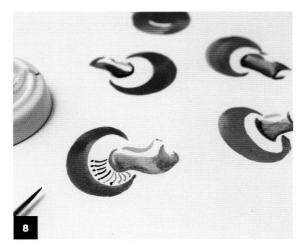

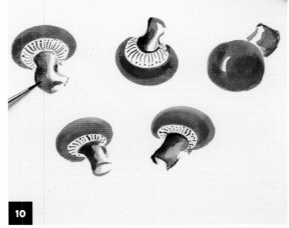

MUSHROOM INSPIRATION

Now that you've mastered the basic mushroom form, experiment and add more forest mushroom varieties to your creative arsenal. Painting fungi is great for improving your skills in creating textures, shapes, and colors. Fill a sheet of paper with different types, such as chanterelles, true morels, ink caps, coral mushrooms, or gilled polypores.

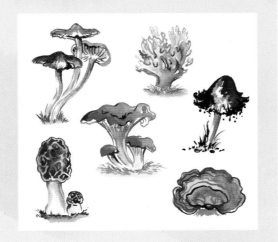

8 Draw stripe outlines with the size 3 round brush on the rest of the mushrooms. I used green to complement the vivid purple-pink of the cap.

Paint the gills, the little ribs underneath the cap, using the darker stipe outline color mix and a small round brush (size 1, 2, or 3). These tiny elements are crucial for giving a simple mushroom a three-dimensional feel. Paint lines with a dot at the edge of the cap, following the radial direction of the stipe.

9 Experiment with painting the gills in different colors and line widths. Make sure you maintain the angle and orientation of the lines, which radiate from the center under the cap.

10 Create interest and depth by adding a large shadow stroke to the cap. Use the same color as the cap or darken it a bit with green or violet.

Using any brush, add a large stroke on one side of the stipe with its original color to create a shadow and lend a three-dimensional feel to the mushrooms.

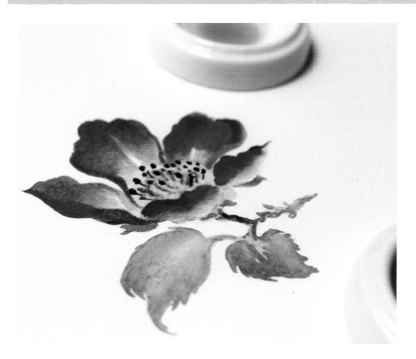

MATERIALS

Template (see page 122)

Pencil

Watercolor paper: cold press, 100% cotton, 300 gsm

Drawing inks: bright pink, green, and warm yellow

Brushes: synthetic round, sizes 3 and 6

In this lesson, you'll create an inky rose, also known as a show-stopper of the garden, using gradient effects and a glazing technique. Roses come in many types and varieties, and I love combining them, playing with petal gradients and bright accents in the center.

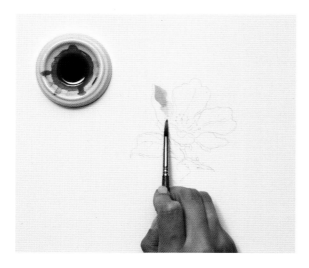

1 Using the template or a reference image of a rose as a guide, draw the rose lightly in pencil on watercolor paper. Begin inking the upper petals using the size 6 round brush. Starting from the top of the petal on the left, apply the ink, moving toward the middle of the flower. Use the one-color gradient technique (see page 36) to color the petal. Start with a darker value of slightly diluted bright pink ink and move to the middle of the petal, diluting the ink until you are left with the white of the paper.

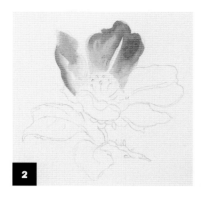

2

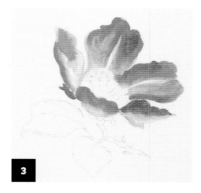

3

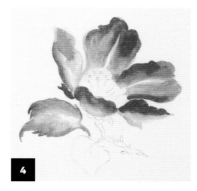

4

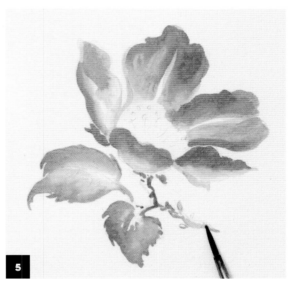

5

2 Continue working on the petal to the right in the same way. Be sure to leave a white stripe in the middle of the petal to suggest its curved shape. Notice that the left side of the petal has a slightly bent edge; making it light creates the illusion of depth.

3 Paint more petals, leaving white space as highlights here and there. Change the ink intensity to achieve a subtle or bold look. The gradient of bright pink to the white of the paper should be smooth and subtle, but it doesn't have to be perfect. When inking a stylized flower, we're aiming for a general impression. Usually, the transition of color for all the petals begins with a darker value on top, with the ink becoming almost transparent closer to the stamen, but it doesn't always have to be the same. Change the direction of the gradient to add interest and intensity.

4 Paint the edges of the leaves with green ink and the size 3 round brush. Leave the middle of the leaves white, creating a beautiful color transition. Keep the first layer fairly transparent because a layer of yellow ink will be added later. Brush the ink in any direction that's comfortable. I prefer placing the rounded brush flat to cover a larger area with one stroke. Allow the ink to dry.

5 Continue painting the leaves and stem with green ink and the same brush. Remember to leave some white space in the middle of the leaves and on the stem to create an interesting visual texture. Note how the stem is uneven, which can be shown by making some parts lighter. If you feel the value is too dark, rinse the brush with clean water and dab it on the area you want to lighten while the ink is still wet. This allows you to lift off parts of the color.

(continued)

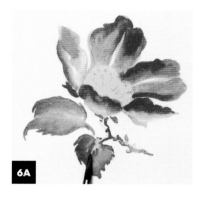

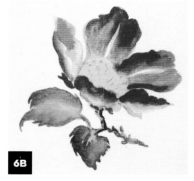

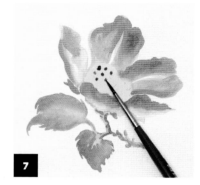

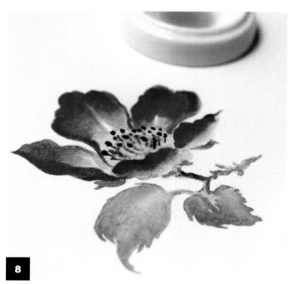

6 Paint the white parts of the leaves light yellow **(6A)**. Glazing the leaves creates a glowing effect, especially if you tested how the inks would optically mix (see page 30). Dilute warm yellow with a bit of water to get a lighter hue, or add another bright yellow shade, such as lemon yellow. Glazing the leaves this way produces a brilliant middle (where it was left white), and the rest of the leaf takes on a rich green-yellow hue. Add bright yellow to the middle of the flower and a little bit at the base of the petals. Water down the ink a bit to transition to the first layer of bright pink in the petals **(6B)**.

7 Paint the stamens with a dark shade of ink or mix purple and green in a 1:1 ratio. Dab the size 3 round brush in the ink and make tiny circles for the stamens. Vary the intensity of the ink to add interest to this pattern, making some marks lighter than others.

8 Paint several fine lines from the circles toward the middle of the flower to finish the stamens. To create a crisp line, make sure the base layer of ink is dry. I wanted a blurry effect and painted the stamens while the ink was still wet.

9 Add another layer of purple on the petals and green on the leaves to increase the intensity of the colors. Don't cover the entire petal with this opaque hue. Keep the look of the flower interesting by maintaining white space and the gradient.

LESSON: ABSTRACT LEAVES

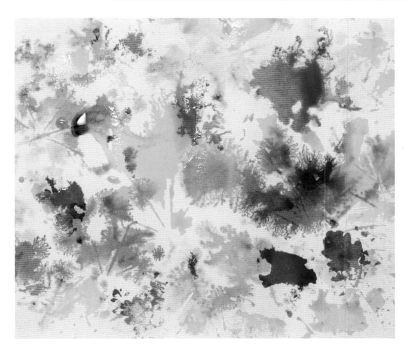

MATERIALS

- - -

Fresh leaves in various
 shapes and sizes (you
 can also use dried
 leaves and grasses)

Dye-based inks:
 turquoise, lemon
 yellow, and rose

Porcelain or plastic
 palette with several
 wells and a flat
 surface

Pipette

Brushes: large synthetic
 paintbrush and large
 mop or flat brush

Watercolor paper: 100%
 cotton, 300 gsm

You'll love this abstract printing technique if you want to create something unique that can't be repeated in any way. Colored inks can show amazing properties when applied in an abstract manner. The method is adored by surface pattern designers and looks great on fabric.

In this lesson, you'll use leaves as brushes, a technique I love because leaves provide a onetime texture. You'll use ink on the surface of leaves to make paintings that reflect the characteristics of their veins, structures, and shapes. You'll be amazed at how many beautiful abstract pieces you can easily create with natural objects.

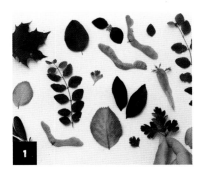

1 Arrange the leaves so you have a great selection for painting. These leaves were picked in summer, but in fall you might be inspired by the treasures you can find in shades of orange, yellow, purple, and red.

(continued)

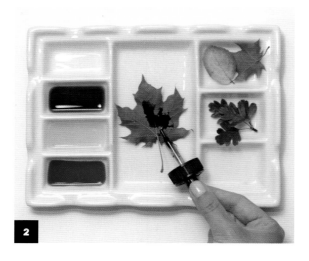

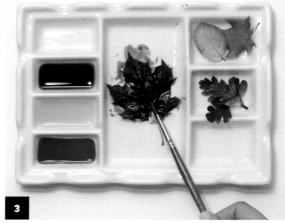

2 Prepare the inks by diluting them with water until they're the desired shade (they can be any value). Siphon some of the diluted turquoise ink from the well with a pipette and apply it to the back of one leaf. You can also apply the ink to the leaf with a brush or drop some ink onto the flat part of the palette and dip the leaf directly into it.

3 Spread the ink with the brush so it covers the surface of the leaf. Be sure to spread ink all the way out to reveal the crisp leaf edges.

4 Prepare the watercolor paper by wetting a large area of the paper with clean water and a mop or flat brush.

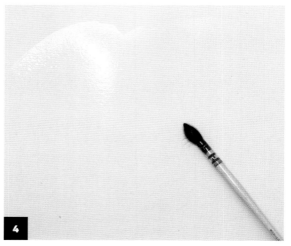

TIP

Try pressing the leaves on wet, damp, and dry paper to get a variety of abstract effects.

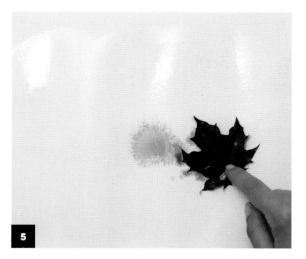

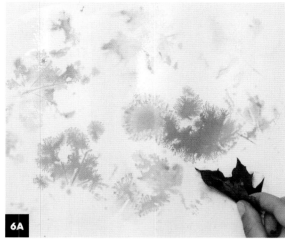

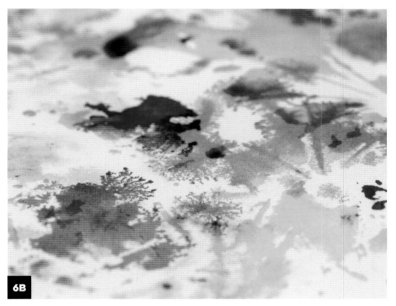

5 Press the inked leaf onto the paper while it's still wet. You can see the magic is already starting to happen.

6 Repeat step 5 and press the leaf onto the paper where you think it fits **(6A)**. Change the angle, pressure, and intensity to achieve a variety of shapes. Include the other colors, working intuitively and creating appealing contrasts. The intricate patterns of the leaf veins will appear where the paper is drier **(6B)**.

TIP

You can print and paint with almost anything, such as vegetables, feathers, berries, potatoes cut into shapes, fabrics, etc. If an object has a slick surface, it may repel the ink. To help it accept the ink, rub the surface with soap and water. If you need to press an object harder to get a print, place a stack of paper towels on top of the object and press it for a better effect.

LESSON: BOTANICAL MANDALA

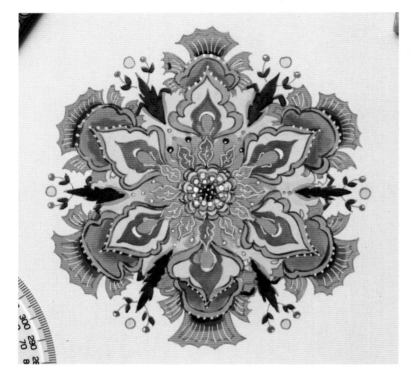

MATERIALS

Bristol paper: 250 gsm

HB pencil

Circular protractor or
compass

Permanent fineliner ink
pen, any color

Alcohol ink markers

White gel ink pen

The satisfying symmetry of a mandala has a special meaning that's unique to every creative. Some people use it for meditation or mindfulness, and others use it to create a fulfilling design of unifying shapes.

The design of the mandala can be intricate with a lot of fine details or very minimalistic, offering simple beauty. The number of details you want to include in your artwork depends on your artistic taste. I've always loved intricate designs, and even as an absolute beginner added as many swirls, leaves, and curves as I could fit into a shape. Some artists, however, prefer minimal arrangements and include just a few elements in their work, which can look stylish and elegant.

Working in a sketchbook and collecting ideas, doodles, and shapes for future designs is helpful. Anything that makes you happy can be turned into inspiration. If you love nature, take photos during your walks outdoors or in a garden to discover how flowers are constructed. Or listen to some music, look at books and magazines, and note all the graphic elements of your favorite objects.

Although an intricate mandala can be created in several minutes with a few clicks in Photoshop, nothing compares to the authentic experience of using physical art supplies and the enriching journey they provide. In this lesson, you'll create a botanical-inspired mandala and use alcohol ink markers to make it come to life with color.

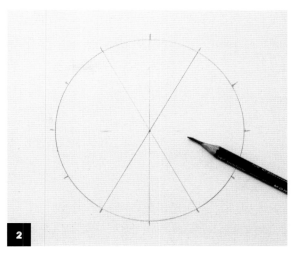

1 Draw a circle onto the Bristol paper using a pencil and a circular protractor or compass. My circle is about 5½" (14 cm) in diameter, but you can make it any size. Mark the middle point.

2 Divide the circle into twelve even sections and draw lines through the center point to create a grid. Mark every third degree using the protractor to create even sections.

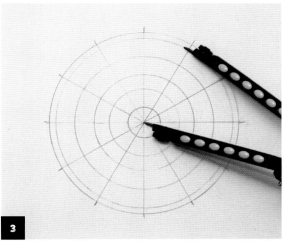

3 Place the compass needle in the central point and draw several concentric circles in various sizes. No precision is needed; some people prefer drawing mandalas using no grid.

4 Draw an intricate ornament in any area of the grid with the fineliner pen. I was inspired by flowers and trees, which resulted in a variety of natural shapes.

(continued)

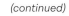

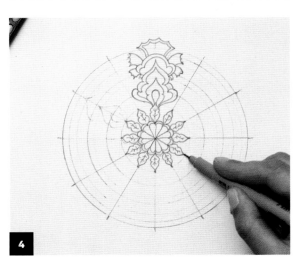

5 Take your time and fill the entire grid with simple or elaborate designs. Rotate the page as you work so you can comfortably reach various sections. Keep smaller elements closer to the middle and larger shapes toward the edges, making the mandala bloom. Alternate large, rounded shapes with sharp, pointing designs to add interest and maintain balance. If you like detailed artwork, fill the white spaces with small patterns of circles, swirls, leaves, and lines. Trying a few combinations of such patterns on a separate sheet of paper will help you feel more confident in your choices.

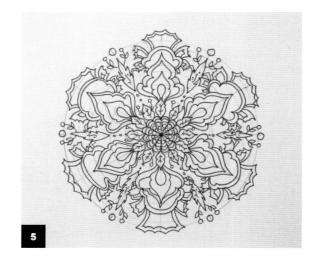

6 Plan how you want to color the mandala. A nice feature of alcohol ink markers is that they can be blended without using water. Test the markers on a separate sheet of paper before using them. Make a few strokes with yellow, a few with orange, and blend the gradient with yellow by working over the whole area, smoothing the edge between the hues.

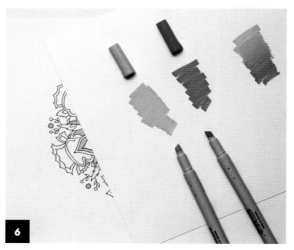

7 Choose the palette you want to work with and test it on a separate piece of paper. It's best to alternate large areas of color with smaller ones. Using complementary colors (see page 29) is an effective way to make a mandala pop. For example, I've broken up some warm-tone areas with small pops of turquoise. I used dark blue and green for tiny graphic leaves and elements to create accents. Putting dark and light areas close together adds dimension and visual contrast to your work.

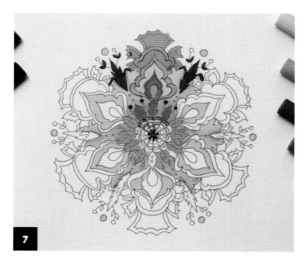

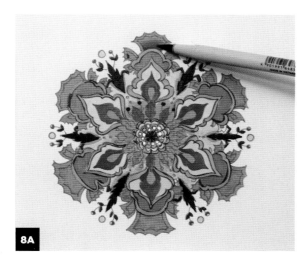

8 Add depth to the piece. I created a gradient on the larger outside petals by brushing magenta and violet onto the sections and using magenta to blend the colors **(8A)**. After blending the ink on the paper it will become even smoother over time. Make sure to blend analogous colors (see page 29), or the colors and the design will look messy **(8B)**.

9 Adding final touches will make the mandala pop even more. Use a white gel pen (or a similar white pen) to define some of the lines and add highlights here and there. I added symmetrical dots on the edges of the berries, loosely outlined the shapes of the inner circle of leaves, and added curved lines to the outermost petals.

Your marker lines and designs don't have to be perfect! The magic of the mandala is in the process and its overall impression. Even if the separate elements are a bit out of line or messy, the piece will look cohesive and shine.

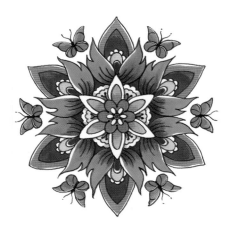

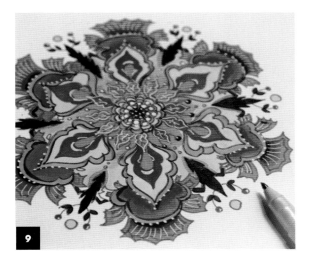

Here is another botanical mandala for inspiration. Six simplified tulip buds are outlined with a violet ink liner pen in a graphic, stylized manner, then colored using alcohol-based markers. Butterflies as bright accents add liveliness and interest.

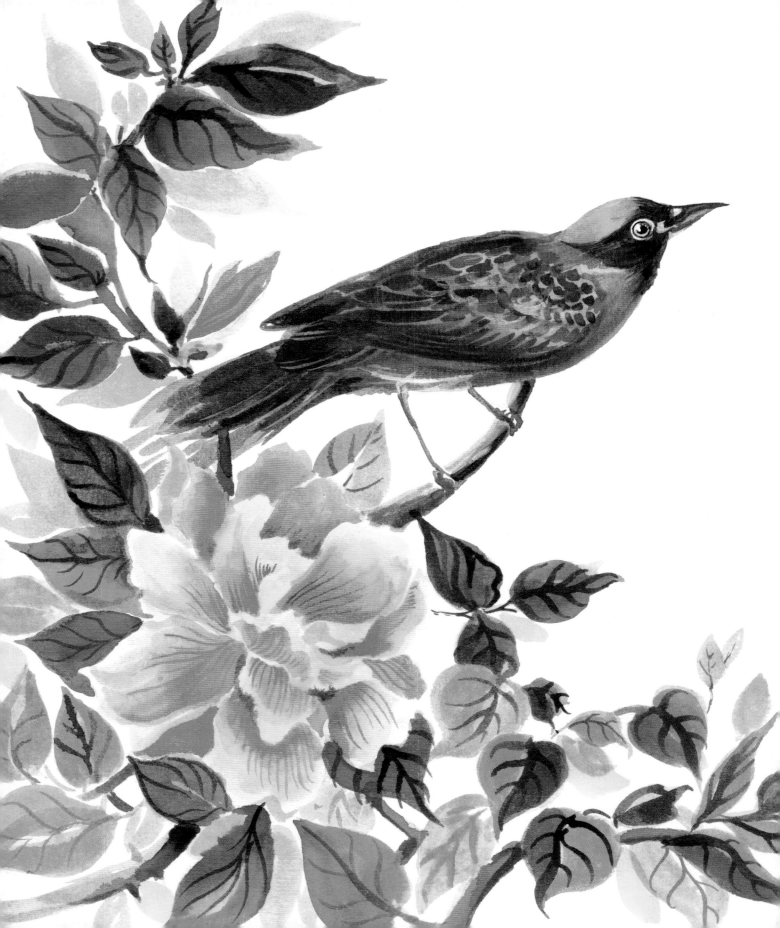

4

ANIMALS AND BIRDS

In this chapter, you'll explore the fascinating world of creatures who live above ground. Birds, butterflies, and animals living in trees symbolize traveling to other realms. What could be more inspiring for an artist?

In these lessons the focus will be on essential elements such as combining colors, creating the look of fur with ink, painting vibrant feathers, depicting expressive eyes, and simplifying details to create a unified impression. You'll create vibrant artwork in just a few steps using simple shapes that catch the viewer's attention. Let's take off!

LESSON: BUTTERFLY

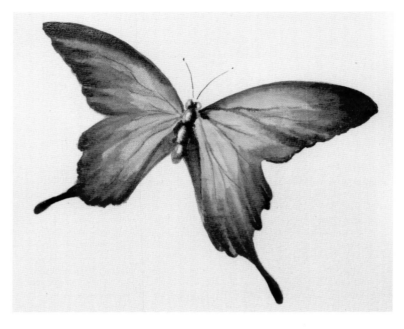

MATERIALS
- - -

Template (see page 123)

HB pencil

Watercolor paper: cold
 press, 100% cotton,
 300 gsm

Drawing inks:
 cobalt, turquoise,
 ultramarine,
 and yellow

Brushes: synthetic round,
 sizes 3 and 6

Painting butterflies in ink can be a fun, creative exercise because you can invent your own patterns and use imaginative, brilliant colors. In this lesson, you'll create a morpho butterfly with open wings using three hues of blue: cobalt, ultramarine, and turquoise. Throughout the process, you'll discover how combining three similar colors creates an alluring and dazzling effect.

1 Using the template, another reference, or your imagination, draw a simple butterfly outline with pencil (it can be any size you're comfortable working with). Color the butterfly using the wet-on-wet technique (see page 38): Brush clean water on the right wing and, while the paper is still wet, apply a light layer of turquoise ink with the size 6 round brush.

2 While the paper is still wet, dab the same brush into cobalt ink and paint the edge of the wing. This creates a gradient and the inks will mix directly on the paper. Slightly wet the brush with clean water and smooth the borders between the colors.

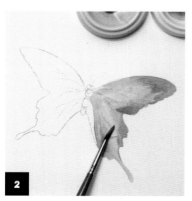

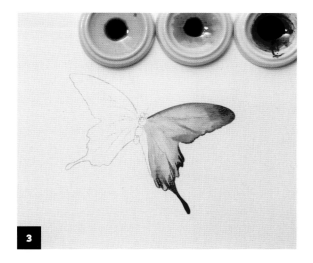

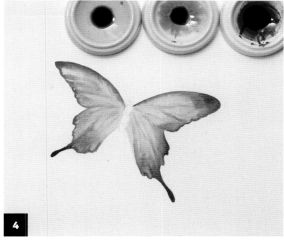

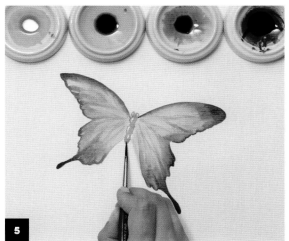

3 Repeat step 2, using ultramarine ink and the same brush. Brush ink only at the edges and smudge it with a slightly wet larger brush to create a seamless color transition.

4 Repeat steps 1 through 3 on the left wing. Let your brush fly! Add a few strokes here and there to create a hint of the veins in the wings. Continue working on a slightly damp surface to maintain a unified look.

5 Color the butterfly's body with warm yellow, which provides a nice contrast with the blue wings. Use the size 3 round brush for better control while painting small areas.

6 Add the illusion of depth. Mix yellow with any darker color you've been using and ink two long triangular shapes near the body and inner sides of the hind wings to support and contrast some edges.

7 Lightly outline a few veins in the wings with yellow, using the size 3 round brush. The color will optically mix with blue and create more interest (see finished image, opposite page). If you're not sure about how this mix will turn out, do an optical mixing exercise (see page 30).

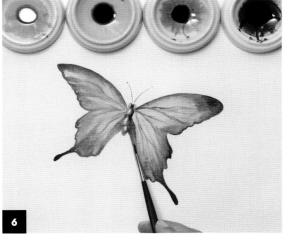

LESSON: COLORFUL BIRD

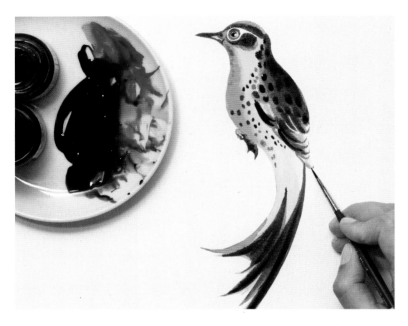

MATERIALS

— — —

Template (see page 123)

Pencil

Watercolor paper: cold press, 100% cotton, 300 gsm (see Tip)

Drawing or acrylic inks: yellow, orange, scarlet, violet, purple, and a neutral tint (*Note:* A neutral tint is a purple-gray color that is neither cool nor warm. This universal shade has many uses, such as unifying a color palette or for shadows.)

Brushes: synthetic round, sizes 3 and 6

Are you fascinated by a particular owl, peacock, nightingale, or sparrow? If so, don't let the complexity of feathers and details stop you from painting them. Use anatomical diagrams that show the crown, forehead, beak, eye, wing, breast, leg, back, and tail or draw your own imaginary winged creature.

The secret technique of depicting a bird is dividing the image into simple shapes and inking them separately, creating a unified impression. The feathers can be painted as simple strokes that suggest their downiness and volume. The cheerful and bright effect of a colorful bird can be achieved with as few as three to five colors.

TIP

Choose a thick watercolor paper that holds a lot of water if you plan on adding layers of ink. Cold press paper is more forgiving, while the smooth surface of hot press paper absorbs a first layer of ink quickly, making it more difficult to blend colors, make any changes, or lift off the ink. Bristol paper is acceptable if you work in a light style with just one layer of ink.

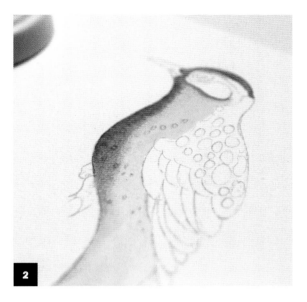

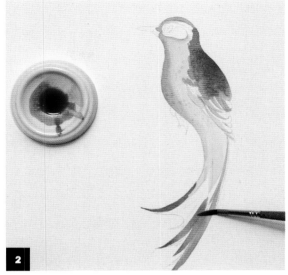

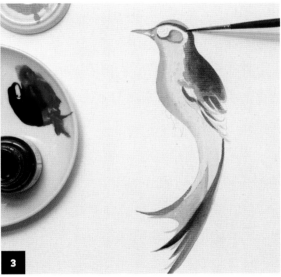

1 Using the template, a reference image, or your imagination, sketch a real or imaginary bird with clearly defined shapes for the head, wings, and tail that will be inked. The most important part of the bird is the head, since its eyes make a connection with the viewer, so I defined the eye area by drawing a circle around it. Fill in the bird's breast and lower tail feathers with warm yellow.

2 Add a bit of scarlet or orange on the edge of the breast and the head while the yellow ink is still wet using the size 6 round brush. A gradient will emerge. Working with analogous colors on a large area is an effective strategy. Ink areas of the wings, tail, and crown with purple.

3 Define the crown area, beak, and a few feathers with violet using the size 3 round brush. Try making uneven brushstrokes to suggest depth. Diluting the inks with water will enrich the tonal values. Be sure to leave some white showing on the wing.

(continued)

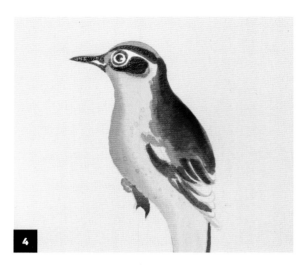

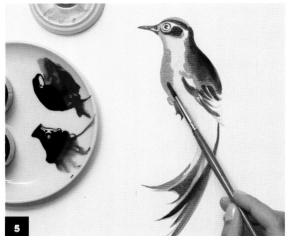

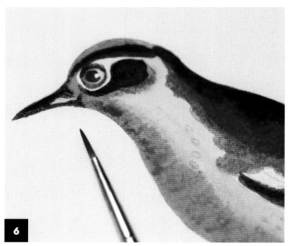

4 Define the sparkling eye and the areas around it with the size 3 round brush and a neutral tint that looks like faded violet. Add a few strokes here and there of that color on the tails and wing—don't fill in the entire area. Use the neutral tint to define part of the foot.

5 If a color seems too subtle, wait until it dries completely and add a second layer. The more diluted the inks, the more layers the paper can absorb. Shellac ink can become glossy after applying a few layers, so if you don't want that effect, plan ahead. Allow the ink to dry completely.

6 Paint half of the eye with yellow and the other half with carmine or orange, creating an impactful look. Use the size 3 round brush. Leaving white space around the eye helps visually organize the focus and draws the viewer to the most important area.

7 Prepare a mix of your darkest colors; I mixed violet and the neutral tint. Areas with the deepest colors attract attention and help the eye focus on them. This bird has a peculiar pattern that I scattered on the upper wing and supported with oval strokes on the feathers.

When the ink on the body is completely dry, add a few ovals and dots on the yellow area of the body. Vary the intensity and direction of the dots to create the illusion of depth.

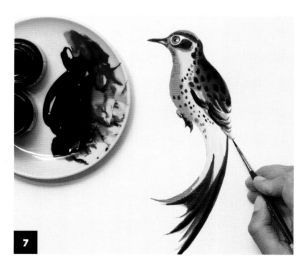

LESSON: RED PANDA

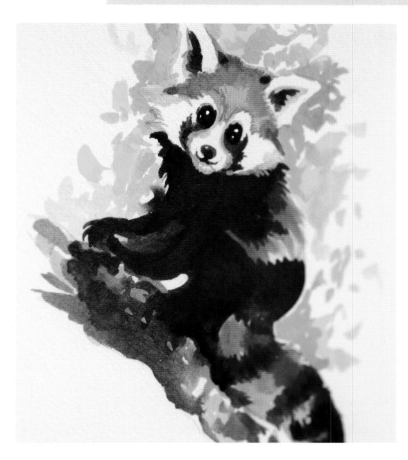

MATERIALS
- - -

Template (see page 123)

Pencil

Watercolor paper: cold press, 100% cotton, 300 gsm

Drawing or shellac inks: yellow, orange, carmine, sanguine, neutral tint (see page 70), yellow-green, and white, or white gouache (optional)

Brushes: synthetic round, sizes 3 and 6

This adorable fluffy fellow is as fire-colored as a red fox and reminds me of both a raccoon and a big cat. In this lesson, you'll draw an irresistible red panda. You'll use just six colors and stylized shapes to capture the impression of this unique creature.

(continued)

TIP

If you need photo references for specific animals or birds, search for its scientific name as well as its common name. The red panda's scientific name is *Ailurus fulgens*. Scientific names usually appear in parentheses in the beginning of an encyclopedia entry.

1 Using the template or your own drawing, sketch clearly defined areas of dark and light elements. To make the red panda recognizable, we need to pay special attention to its individual characteristics. The panda's bushy tail has a few ochre rings; define them with orange or yellow, adding more than one layer if necessary, using the size 6 round brush. Keep in mind the direction of the fur as you paint. You don't need to be precise, but this helps unify the artwork.

2 Combine sanguine with the neutral tint in a 70:30 mix and paint the eyes and the distinctive dark tear markings on the panda's face. Use the size 3 round brush for better control of the ink. Define the nose with a lighter wash of the neutral tint to complete this adorable face.

3 Prepare a dark reddish mix of sanguine, neutral tint, and a bit of orange for the fluffy body and define general masses on other areas, such as the tail. Use the size 6 round brush. The red panda has long fur, so use a large brush and add enough color to show the thickness and volume. Add a few more marks on the ears and face with the same color, defining the markings that are similar to those of a raccoon.

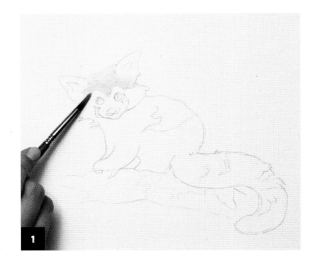

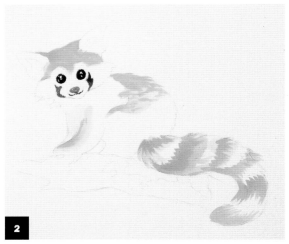

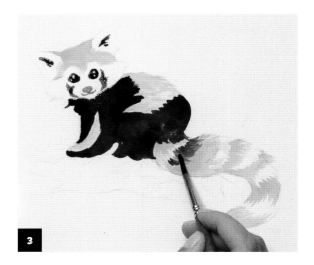

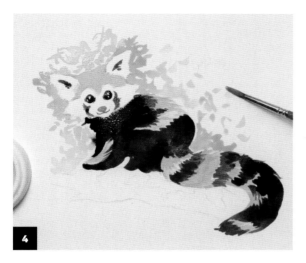

4 Make several rough brushstrokes with yellow-green ink to create greenery around the head. The panda has a very light and rounded upper body with a few white areas and adding some green will make them stand out.

5 Define the tree branch using the size 6 round brush and inks from the previous mixes, such as sanguine with neutral tint for darker areas and yellow-green for lighter ones. Make a few brushstrokes that suggest texture. Focus on the face, because this has the most detail and is a focal point. The rest of the artwork supports the general impression of the piece, so it can be less detailed.

6 Further define the tear marks on the face and inner parts of the fluffy ears with a light wash of sanguine and the size 3 round brush.

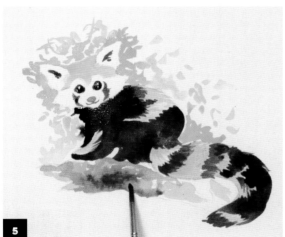

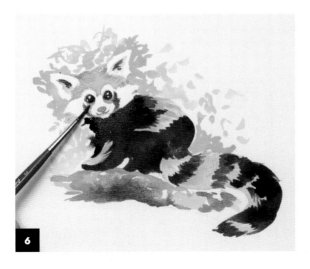

TIP
It's easy to correct tiny mistakes or emphasize some facial features at this stage. Use white ink or white gouache to broaden and reshape white areas and use the darkest color to intensify the sharp details.

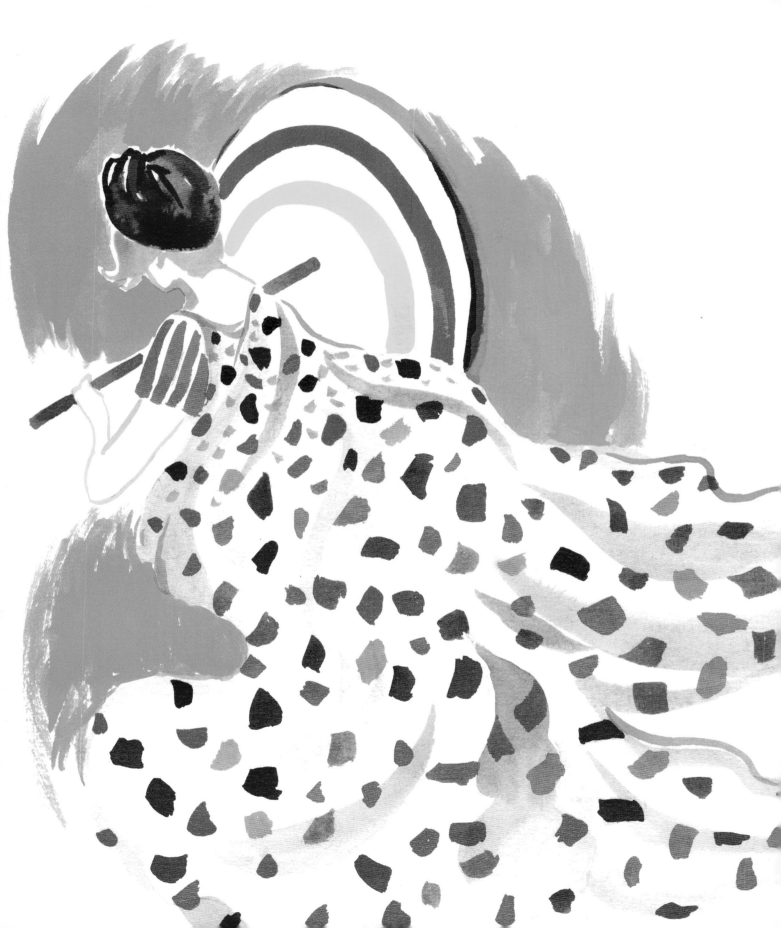

5

FIGURES, PORTRAITS, AND FASHION

- - - - - -

For a creative artist, there is no bigger mystery than our fellow humans. In this chapter, we'll explore various ways of depicting people. You'll begin with a simple stylization frequently used by urban sketchers to enliven city scenes. I'll share what I think makes a portrait expressive and unique.

You'll also delve into fashion art, which is full of creative freedom, whether you're painting garments or accessories. I recently collaborated with the Paris-based high-end fashion house Maison Margiela, and it was a fantastic experience. I contributed my work to the film *A Folk Horror Tale*, a movie based on an original concept by designer John Galliano and directed by Olivier Dahan. I hand-painted a pair of waders spliced with wooden Tabi clogs, with contemporary illustrations in the style of Delft Blue, distorting its classic imagery into motifs that look pretty from afar but reveal a more sinister reality when studied in detail.

LESSON: STYLIZED FIGURES

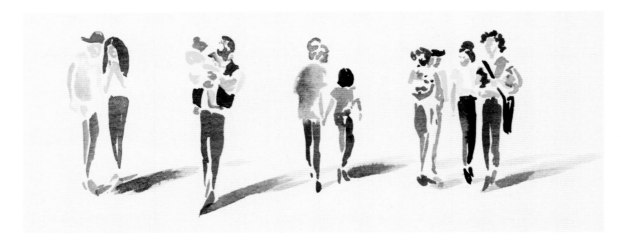

Drawing a figure can seem intimidating, but with inks it doesn't have to be. In this lesson, you'll learn how to depict small figures that can add motion and enliven your illustrations, and you won't have to spend hours practicing anatomy and postures. You'll discover a few key basics that make even a tiny figure look convincing.

1 With pencil, make a few light sketches of long figures that suggest key details such as hair length, shoes, and clothes. Let your imagination fly! These stylized figures don't have to follow anatomy rules, so you can exaggerate or minimize any features to your liking. There's no wrong way to do this. Draw from imagination or find a few photo references of groups of people. Begin by inking the legs of the first figure wearing jeans. Using the size 3 round brush, make two long strokes with cobalt ink and unite them on top. The strokes should be short, no larger than your index finger, to form the figures. It's easier to depict legs in the standing position than, for example, running or jumping.

MATERIALS
— — —

Pencil

Watercolor paper: cold press, 100% cotton, 300 gsm

Colored inks: carmine, neutral tint (see page 70), green, pink, sanguine, yellow, orange, and cobalt (any type of ink will work)

Brush: synthetic round, size 3

1

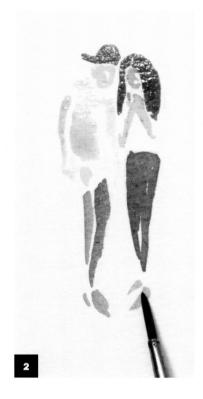

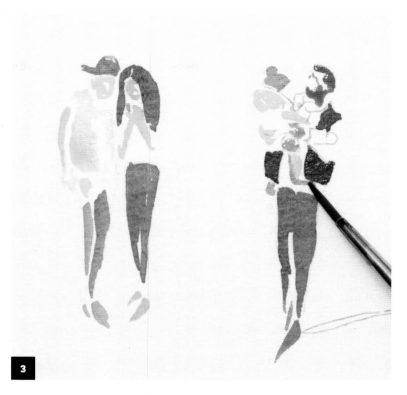

2 Working small allows you to simplify what you see. Draw a couple using short strokes and leave a lot of white space after each element. The white jacket consists of three various strokes and is isolated from other forms, such as the head. This allows you to work quickly and not worry about ink bleeding off the edges. Ink the skin of the first figures with a warm color such as orange, only suggesting the shape of the face and the position of the hands.

3 Use a more abstract and simplified approach to ink this character, who is holding a child. Leave a lot of white space between the shoes and pants as well as all other elements. Use complementary colors to make some parts pop, such as a green jacket with a red-pink hat. Use sanguine slightly diluted with yellow or orange to create a variety of skin tones.

(continued)

TIP

When painting figures, depict people engaged in simple movements, such as walking, standing with coffee, or chatting. Avoid difficult poses such as dancing or running. Also, when painting figures, the size of the head should be a bit smaller in relation to the rest of the figure. Unlike the caricatures where the head is larger, we're aiming for a fleeting general impression.

4 Painting people who are facing away and walking might sound challenging, but not for this stylized inky look. Ink simple shapes suggesting the outfit and general impression of the human form as you did in previous steps. Imagine you have just one or two brush-strokes to ink the head, body, hands, and legs. What is the most important? When you watch people walking away, you notice just a few details, and that's what you should aim for. To show a woman's personality, create a hairstyle with curvy strokes. Paint an irregular shape with an even wash to suggest a tunic. Make two uneven short strokes to ink the legs.

Note that in the left-hand figure of the walking couple on the right, the left leg in the distance seems shorter, so use a shorter stroke and a smaller mark for the shoes. Work the same way on the second character. Paint a *V* shape in orange suggesting the two are holding hands and dab the same mix to ink the side of the face. This principle works well for depicting people in the distance and for avoiding unnecessary details. Don't forget to leave white space between pants and shoes for a better look.

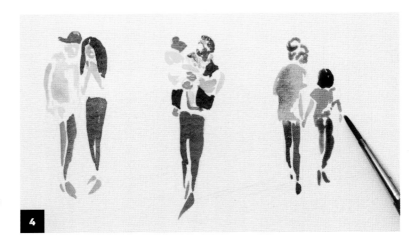

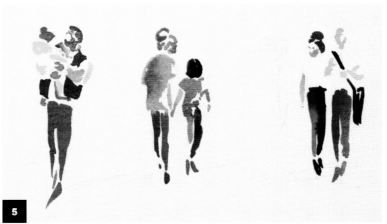

5 Ink another group of people and indicate their profession (seen at far right). Hint at details on a small scale that are easily seen from a distance, such as a briefcase or suit. Begin by inking the legs and separating them from the shoes with white space. Mix cobalt with carmine and make a stroke to create a crossbody bag. Make a few strokes to define the position of the hands and the direction of the faces. Use short, brisk strokes to keep things fresh.

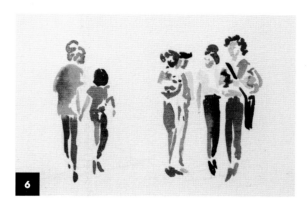

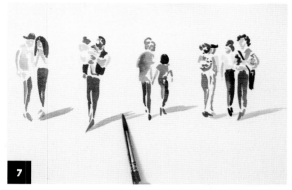

6 Paint a group of people at the far right, separating them into smaller shapes as before. Think of them as a tiny collection of garments and accessories that are put together to form a whole. Use the same colors for the group to unify the piece and bring balance. You can mix various skin tones or values, but the initial hues should still be recognizable. When inking a group, choose the main characters and depict them with more details and paint the others in a sketchier style. Even with a few strokes you can indicate character traits and professions.

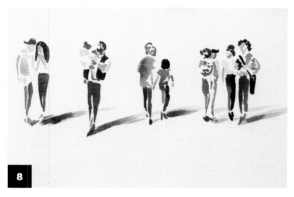

7 Add shadows with a cool or neutral tint (see page 70) to create immediate depth and add a dynamic effect. I used neutral tint with a drop of cobalt near the shoes. Note the sharp angle of the shadow supporting the expressive silhouettes of the figures. This is an artistic trick to add a dramatic feel and interest to the composition when inking stylized people. The size and angle of the shadows depend on where the imaginary light source is. I imagined that the sun was low in the sky, affecting the size of the shadows. Ink the shadows at about three-quarters of the figure's length for a dynamic feel.

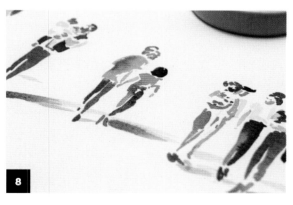

8 Shadows are darker when closer to an object, so add a stroke of cobalt to increase the intensity. Try painting figures with monochrome inks, playing only with lights and darks and keeping details to a minimum. Experiment and paint lots of tiny characters and see what suits your style best.

LESSON: EXPRESSIVE PORTRAIT

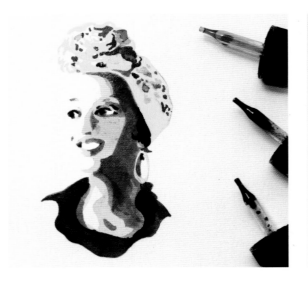

MATERIALS

- - -

Template (see page 124)

Pencil

Watercolor paper: cold press, 100% cotton, 300 gsm

Colored inks (any type): sanguine, red brown, yellow, deep green, orange, and ultramarine

Brushes: synthetic round, sizes 2 and 3

For a long time, I thought expert technique was key in creating a good portrait (especially when I couldn't draw convincingly). But at the same time, I'd see portraits that seemed dull and lifeless, no matter the number of details. To be expressive and move the viewer, a successful portrait should have three components: It should tell a story, convey emotion, and have a personality.

Portraits can be executed in many styles and genres. Even a few brushstrokes can be enough to render a likeness. If you have a personal interest in the subject, that always helps. On the technical side, the shape and the base of the head are most important, and only then do we add as little or as many details as we want.

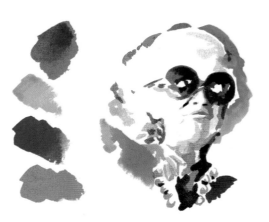

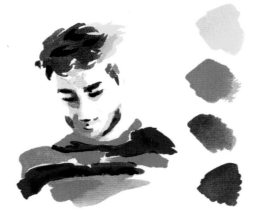

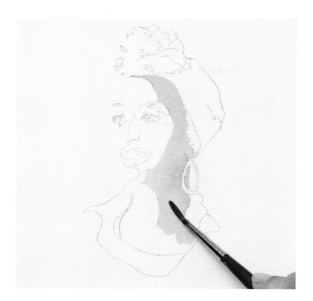

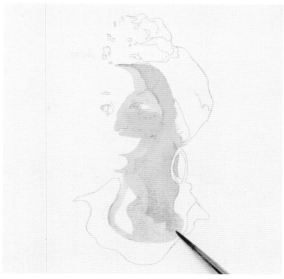

1 Using the template, an inspiration image, or your imagination, make a sketch with simplified proportions and features, defining the darkest areas and shadows. Using straight pencil lines, block in the darkest areas, such as the right side of the face and part of the neck, nose, and lips. If you feel a bit unsure at this stage, that's normal, and don't feel any pressure—just use the template as a guide.

Imagine the position of a light source (here it's on the left side) and paint the large shadow that defines the shape of the face with a light wash of sanguine and red-brown. Use the size 3 round brush for all the steps except for the most delicate details. If you're working with intense colored inks, water down the mix to get a fairly light color. You can darken it with another layer later, but it will be difficult to try to lighten it. Allow the ink to dry.

2 Add a small amount of yellow to the light mix and paint a second shadow that forms the mass of the head and defines the lips. Spread the mix on the initial ink layer, blending the border between the colors, and add more water to the wash if necessary. Although the first layer from step 1 is dry, the ink will optically blend, creating a lovely effect. Leave the eyes, teeth, chin, and neck white.

(continued)

TIP

To create a dramatic portrait, look for reference photographs with sharp, defined cast shadows. A cast shadow is a shadow caused by an object blocking a light source, and it has a distinctive shape and edges. When the light source is clearly seen, we know where to put the shadows and highlights.

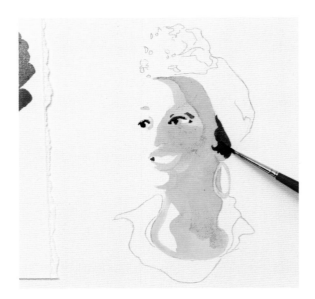 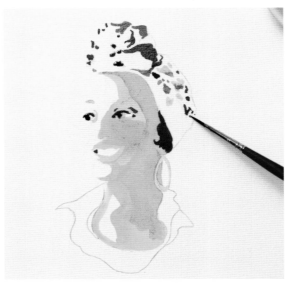

3 Mix ultramarine and red-brown in a 1:1 ratio to get a rich, glowing dark color. Decide which elements you're most drawn to and emphasize them with dark accents. This will be different for every artist; I always choose to intensify the eyes, eyelids, parts of the hairstyle, and the corners of the lips. Paint the eyes, hair, and a shadow on the lips. Don't paint the teeth details or any other small elements that can interfere with the general impression and distract us with nuances. The mouth and smile are the most expressive elements after the eyes, and color plays a huge part in their expressiveness too. We want to keep spirits light and cheerful, so less is more. Allow the ink to dry.

4 Imagine a general three-dimensional shape of the headdress and how the fabric is wrapping around the head. Make several inky marks in various directions to follow the shape you've imagined. Use any colors from your palette to add variety. I used ultramarine, red-brown, and a slightly diluted yellow, applying it with a small brush. Using ultramarine on top helps to contrast the face tone. Avoid outlining the fabric and leave white space between the marks.

TIP

Use a painterly approach for your portrait and avoid using black to keep the dramatic interest and brilliance. Shadows are commonly created with a mix of violet, blue, and brown, which results in a more interesting shadow color. Dark colors can be mixed from a variety of hues, such as a combination of red and green.

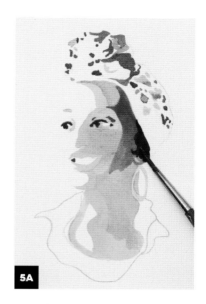
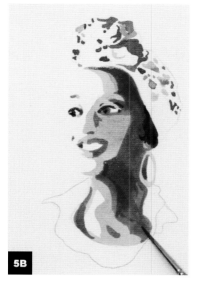
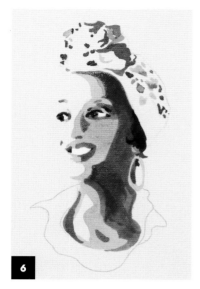

5 Add another layer of the wash of sanguine and red-brown (or any dark wash) from step 1 to emphasize the deeper values on the right side of the head, part of the nose, eyelids, lips, and neck **(5A)**. This wash should be darker, so depending on the intensity of your ink, use just a little or no water at all. Begin with the top right corner of the face, following the hairline. Don't worry if you ink over the hair; the mix will only add brilliance **(5B)**. Use the size 2 round brush for small details. Be sure to ink around the hoop earring and support the general shape of the head by using the same wash for all the elements in the portrait.

6 Define the shadows on the lips, the plane of the nose, and the neck with the size 2 round brush. Carefully add darker shapes around the eyes and unite them with the biggest shadow area. This effect is achieved by using the same dark mix across the whole piece. Think of the shadow areas as small separate blocks. Since you've started by shading the larger area, it becomes easier to see where to put additional smaller shades.

Imagine what lies in light and what's in shadow. Put just a few tiny light, brisk strokes on the eyebrows, another one on the nose plane, and then a horizontal stroke as a hint of a nostril. Add slightly diluted shadow mix to the eyelids. The eyes are usually the focal point of the portrait, so make sure you intensify them. At this stage, after you've made these marks, take a small break, and look at the piece with fresh eyes to see whether everything feels right.

(continued)

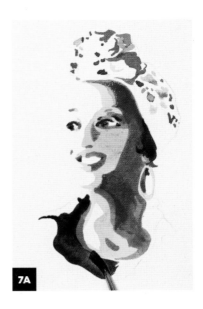

7A

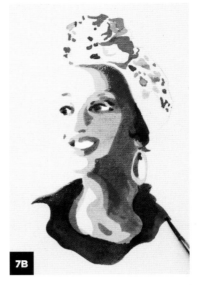

7B

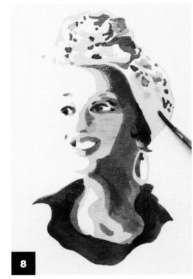

8

7 Decide which part of the clothes you want to show to balance the portrait. Ink the shirt collar with deep green, starting on the left with the size 3 round brush **(7A)**. Halfway through painting, switch to ultramarine right on the paper and continue filling in the shape. Blend the border between the colors if necessary **(7B)**. If you're using enough water or ink, the blending should happen automatically.

This mix not only adds interest but also creates a different visual texture from what you created on the face, separating parts of the image from one another and emphasizing the fabric's velvety texture. Allow the ink to dry.

8 Add final touches with glowing yellow. Ink the headdress, leaving a few white spots at the very top. Fill in the white space on the eyelids with yellow, and anywhere you think it feels right and needs some highlighting. Most of the information lies in the shadow areas of the artwork, so now you can unify the image by calming down white areas with yellow. These areas would otherwise look too bright and grab attention. You can jump from one part of the portrait to another, working with a small brush and adding tiny strokes here and there, as you see fit.

8

You've created a beautiful portrait with several shapes and a lot of light areas. This style may look more finished and impressive than a perfectly rendered, extremely detailed artwork.

LESSON: RADIANT FASHION ILLUSTRATION

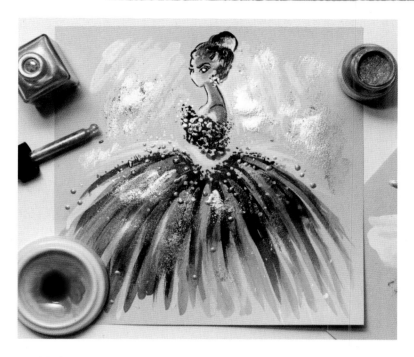

In this lesson, you'll learn how to create contemporary and elegant fashion illustrations using inks on toned paper. Your artwork will shimmer and glow with the addition of metallic pigments.

(continued)

MATERIALS
- - -

Pencil

Toned watercolor paper: beige (or tan), square (8" × 8" [20 × 20 cm]), fine grain, 200 gsm

Shellac, drawing or India colored inks: indigo, Prussian blue, neutral tint (see page 70), carmine, and white (make sure the white ink is opaque)

Brushes: synthetic round, sizes 3 and 6

Acrylic ink: gold metallic

Metallic pigment powder (I used Schmincke Aqua Bronze powder in Rich Gold, but any metallic powder, glitter, or gold mica flakes will work)

Workable fixative

1 Prepare all the materials and test them on the paper you plan to use for the final artwork. Make a few strokes, washes, and marks and, as you work, make notes on your findings:

- How long does it take for the ink to dry? Is it possible to use a hair dryer to hasten the drying time?
- How do acrylic inks interact with India ink or shellac inks?
- How bright and opaque is the white ink on the toned paper? If you want to add bold, impactful highlights, the ink should be opaque (most white acrylic inks are). Semitransparent white ink looks faded and dull on toned paper.
- What's the best way to work with the metallic pigment powder?

2 Using the finished artwork, an inspiration image (fashion magazines are a great resource), or your own imagination, sketch a light figure with pencil depicting the head, neck, and upper torso using only a few lines. Mix a neutral tint or a purple-gray color with Prussian blue in a 1:1 ratio and paint several brisk strokes with the size 3 round brush to outline the head, hair, and upper body.

Choose the pose and perspective for the figure. Dab the size 6 round brush in Prussian blue ink and make a few messy marks defining the corset. Change the angle of the brush to add interest to the marks.

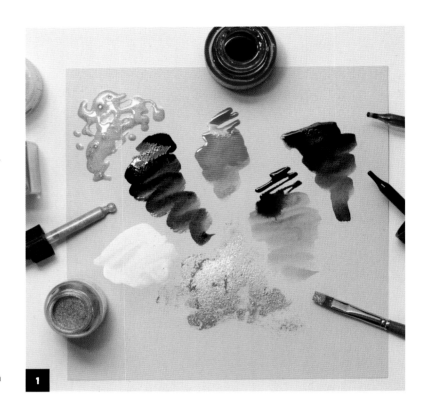

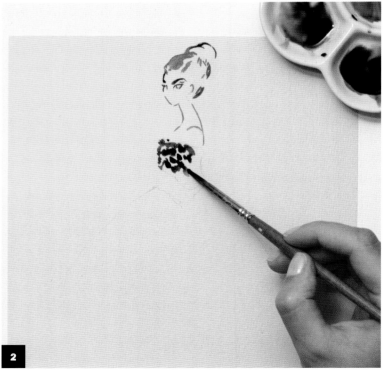

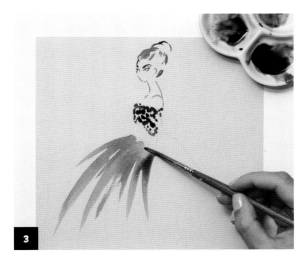

3 Load the size 6 round brush with the color you used for the head and hair and make some bold, confident strokes to define the dress. Try watering down the mixture and continue making broad brushstrokes. Dip the brush in the initial mixture and make new ones. You can ink them on top of or near each other, bringing a spontaneous look. Notice how changing the amount of water adds depth and interest to the strokes even with one layer.

4 While the paper is still slightly damp, load the same brush with carmine and add more strokes to the dress. The ink will mix beautifully on the beige-toned paper and create the illusion of semitransparent layers of fabric. Add a few marks with carmine on the corset too.

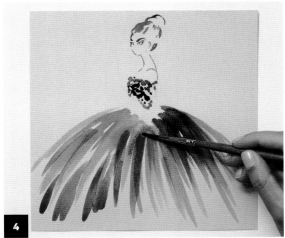

5 Paint a tiny blush oval on the face using a light carmine wash. Allow the ink to dry.

Load the brush with Prussian blue and apply bold strokes on top of the poufy skirt. Imagine there is a sphere shape underneath the skirt and you're painting over it; this will help create the impressive three-dimensional effect.

(continued)

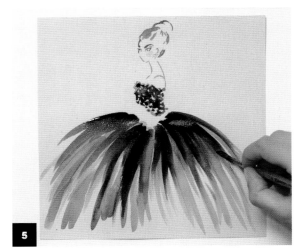

6 Make some dots on top of the skirt and corset using the size 6 round brush and Prussian blue. This helps accentuate these areas by creating a different pattern. Make the same marks near the ear with a smaller brush, creating large earrings.

Make a few strokes on the right side of the figure to create a large shadow on the face, neck, and shoulder, using a light wash of carmine and neutral tint, or carmine and Prussian blue. The wash should be light enough to maintain a general subtle feel in the artwork, but darker than the tone of the paper.

7 Create some highlights. Using the size 3 round brush, apply a few strokes of opaque white ink on top of the skirt to highlight the dots you made in step 6. Carefully add white ink to the left part of the figure, face, and hair, creating highlights (imagine a light source on the left side of the figure). Pay extra attention to the eye and stylize the eyeball, filling it with white. Add a subtle white stroke under the eyebrow. If the contrast in the face is too low, wait until the white ink is completely dry and ink the outline of eyelashes, eyebrows, and hair once again using a dark mix from previous steps.

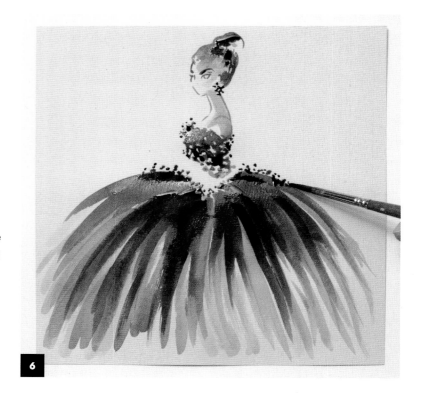

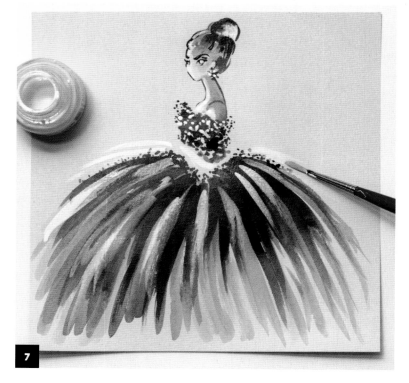

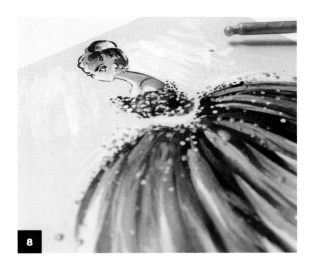

8 Apply the gold metallic acrylic ink to the dress with the dropper, creating a shimmering effect. Avoid creating symmetrical patterns as you drop the ink, following the radial shape of the dress. Create smaller drops close to the waist and larger ones near the edges.

9 When this delicate work is done, take a larger brush, load it with white ink, and add some random strokes on the background to add a modern, grungy feel **(9A)**.

While the ink is still wet, add even more glimmer with the gold pigment powder. The powder will mix with ink or water, and the result is a more brilliant and opaque look than pearlescent paints and inks—and it's one of my favorite techniques. I throw a bit of pigment here and there, adding to the fairy-tale feel **(9B)**. Once the piece is dry, you can protect it with fixative. Alternatively, you can add gemstones, glitter, sequins, shiny beads, or even transparent fabric, such as tulle.

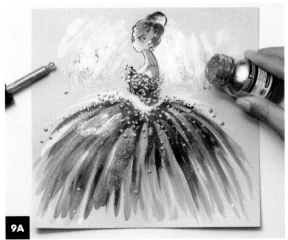

ADD CONTRAST FOR DRAMA

Jewelry and accessories look especially beautiful when painted using a strong contrast of light and shadow. The elements in the perfume bottle are divided into almost abstract shapes. Note how the bright highlights are immediately

supported by dark areas, creating a dramatic look and three-dimensional feel. Keep this in mind when drawing your favorite lustrous object.

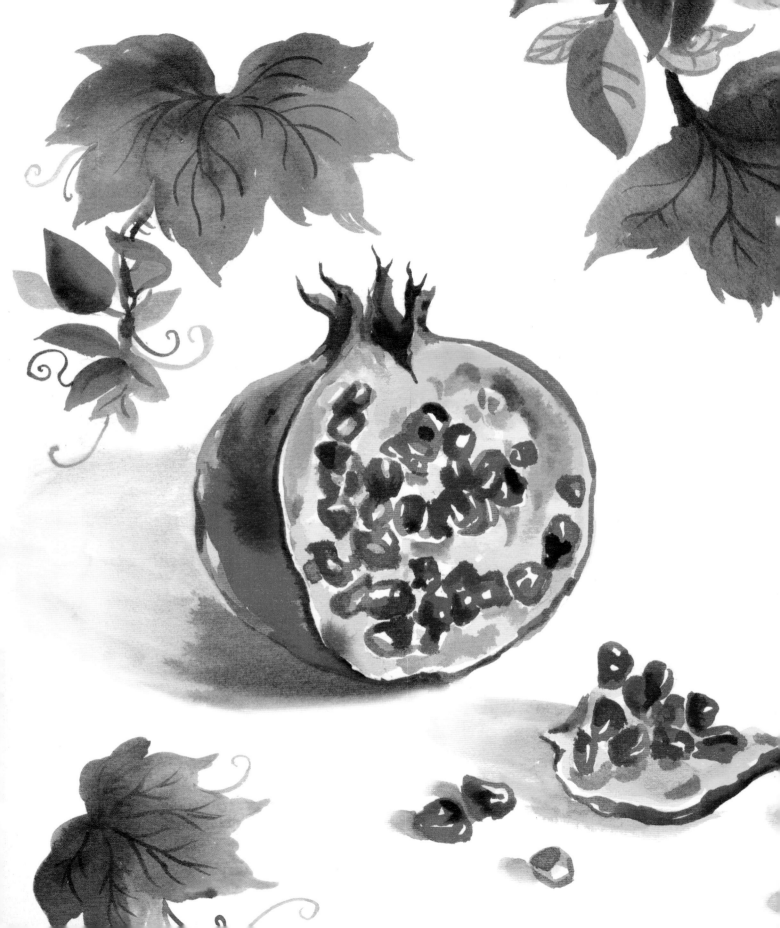

6

STILL LIFE

- - - - - -

Still life is a unique genre that allows the curious artist to explore arrangements, textures, and colors in a variety of inanimate objects. The style originated in the Middle Ages, and paintings often carried symbolic meanings. Still life has evolved into a wide range of interpretations and has become a popular subject for sketching and journaling. Is there a better way to cherish memories than using your journal to draw objects, write notes, create colors, or include anything that inspires you?

In this chapter, I invite you to join me on a trip to Paris and create an inky map while learning new techniques. We'll discover how to draw a pomegranate without painting every seed, and I'll share my secrets for drawing my favorite dessert. Grab your inks and imagination, and let's dive in!

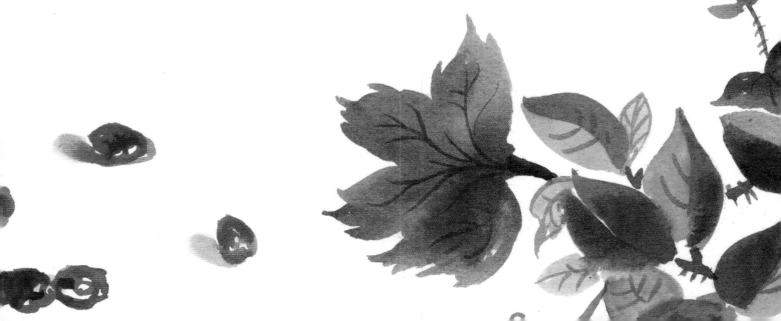

LESSON: PARIS MAP

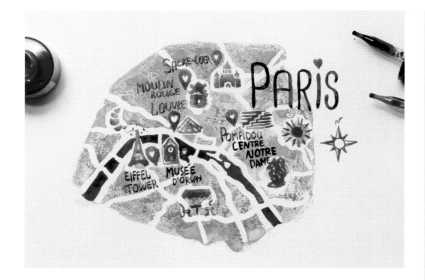

MATERIALS

- - -

Printed or drawn map (at the size you want your artwork)

Light table (you can also tape a sheet of paper on a window)

Bristol paper: 250 gsm, large enough to accommodate the map

Low-tack tape (optional)

Pencil

Masking fluid

Old paintbrush for using with masking fluid (*Note:* Some brands of masking fluid come with a fine-tip applicator that can be used in place of a brush.)

Shellac, acrylic, or India colored inks: yellow, green, red, purple, Prussian blue, and white

Palette

Sponge dauber

Brushes: synthetic round, sizes 2, 3, and 6, and a mop brush, size 1

Rubber cement eraser (optional)

Let's create a stylized map of Paris depicting the most enchanting sites that are my favorite places to visit. Choose any place you love, and even if you've never been there, I'm sure your imagination is fueled with scenes from books, films, and photos to create fantastic artwork.

1 Print a map from the Internet, photocopy a map, or draw your own. Place it on a light table or window and put a sheet of Bristol paper over it (both sheets can be secured with low-tack tape). With pencil, trace the most significant landmarks of the map (your map doesn't have to be topographically correct). For this map of Paris I included the Seine river, a few major roads, and the Louvre Museum, Eiffel Tower, Moulin Rouge, Sacré-Cœur Basilica, Notre-Dame Cathedral, Musée d'Orsay, and Pompidou Centre. Draw simplified icons that represent the places on the list.

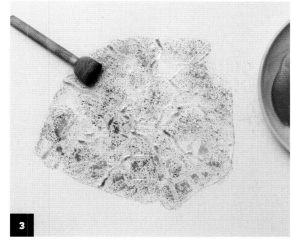

2 Cover all the main roads and landmarks with masking fluid using an old brush or a fine-tip applicator. This will protect these areas from ink. Allow the fluid to dry.

3 Pour purple ink onto a palette and dab a sponge dauber into it. I mixed purple with white to get a light purple hue. I also didn't mix them thoroughly, which resulted in an uneven color and visual texture. Cover the entire map, making sure to pounce the sponge straight down on the paper. Apply color a few times to achieve the desired density of the marks. Try adding color with brushes and paper towels as well. Allow the ink to dry.

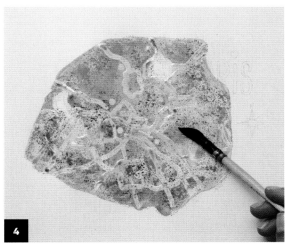

4 Apply a light wash of the same color from step 3 over the map with the mop brush, completely filling out the silhouette. Allow the layers to dry.

5 Remove the masking fluid by rubbing it away gently with your fingers. You can also remove it with a rubber cement eraser, but I wanted to keep the pencil marks, since they'll be handy for inking the lettering and landmarks. Paint the river with ultramarine, using the size 6 round brush. Avoid painting the bridges for now.

(continued)

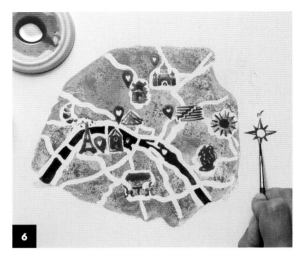

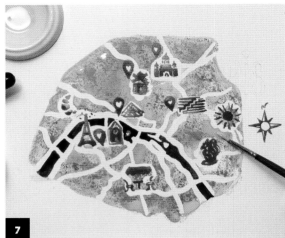

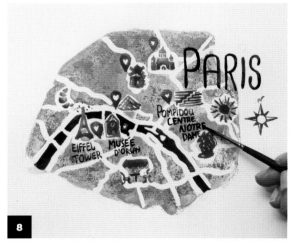

6 Ink the landmarks in red with the size 3 round brush. Paint small geolocation signs at some of the landmarks. Add other related icons; I included a croissant and a café table and chairs. Paint a wind rose in red with the same brush adding an "N" indicating north. (A wind rose is also known as a compass rose or a rose of the wind. All show the cardinal directions: north, south, east, and west.) Allow the ink to dry.

7 Create a pastel mint color by mixing green and white. This provides a nice contrast to the main map colors. Use the size 2 round brush to paint several areas of greenery around the map indicating parks and supporting the design of the city.

8 Letter the name of the city and places of interest with Prussian blue, or any dark opaque color, and the size 2 round brush. Use your print handwriting, which will make the map look personal and authentic.

9 Apply a second layer of ink in areas you want to be more opaque or darker and touch up any details. Make sure you included all the elements you wanted. Fill in empty spaces with tiny people or additional labels. You can scan your map and use it as a postcard or poster.

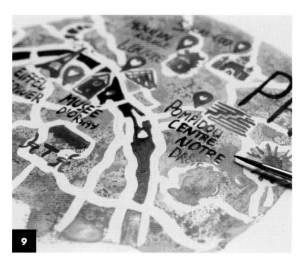

LESSON: POMEGRANATE

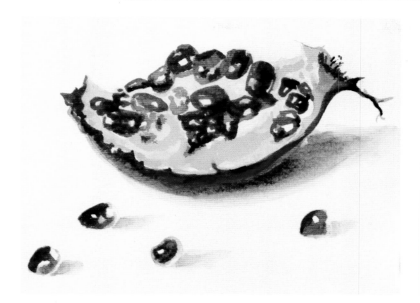

MATERIALS

— — —

India or shellac colored ink: warm yellow, light yellow, carmine, and spring green

Palette

Brushes: synthetic round, sizes 3 and 6

Watercolor paper: cold press, 100% cotton, 300 gsm

Looking at pomegranates, you might wonder how it's possible to draw that many seeds. Have no doubt—it's much easier than you think. This ancient beauty is created with a minimalistic modern approach that preserves the ruby glow. The secret lies in the limited color combination and the grouping of shapes.

1 Create a brilliant orange-red for the outside of the pomegranate. I find that a 60:40 mix of carmine and warm yellow is perfect for inking fruits, berries, and flowers. Try mixing some reds and oranges you already have in various proportions to get a lustrous combination.

2 Ink the rind with the size 6 round brush, changing the coloration of the mix directly on the paper by turning it into a gradient (see page 36). Since the pomegranate's peel has an uneven color, create a mixed gradient. Make the color darker closer to the tip. Use a smaller size 3 brush to make finer lines.

(continued)

3

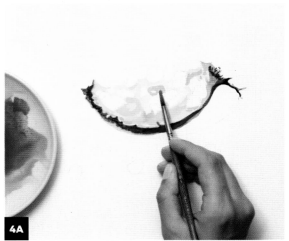

4A

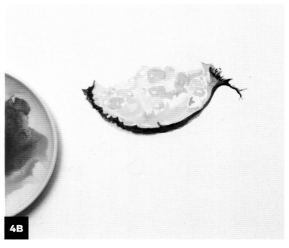

4B

3 Paint the large areas of the pulp membranes with light yellow, using the size 6 round brush. Paint around where the groups of seeds will be, leaving the white of the paper, and don't worry about the direction of the strokes. The membrane has a matte texture to it, so even irregular strokes and marks will look appropriate. There should be a strong contrast between the rind and the pulp. Darken the rind by adding another layer of the orange-red mix from step 1.

4 Painting the seeds is quite easy. Paint oval seeds using a diluted carmine wash **(4A)**. Using the size 6 round brush, cover the white space left in step 3, but don't fill it completely. Imagine you're inking small groups of seeds that look like spots of ink, not separate seeds. Be sure to leave some white highlights here and there on the seeds **(4B)**.

5 While the ink is still wet, load the size 3 round brush with undiluted carmine and dab it on the seed in various spots, creating the illusion of three-dimensional shapes. Maintain the white areas as highlights.

5

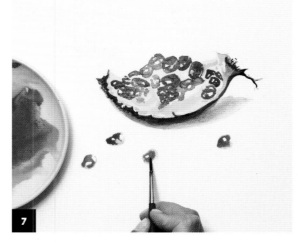

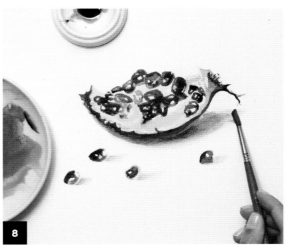

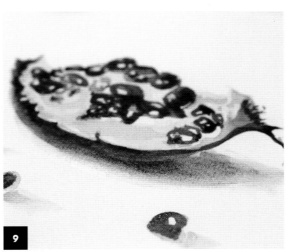

6 Once the rind has dried completely, create a shadow underneath the pomegranate using the size 6 round brush. Add a small amount of green to the carmine wash and paint a semioval under the fruit, adding a lot of water. Note that the shadow should be darker near the subject and slightly dissolve farther away.

7 While the shadow dries, ink some scattered seeds. Repeat steps 4 and 5, starting with a light wash and dabbing darker ink around the white highlights to sculpt the shape of the seeds. Add a light angled shadow under each seed. Allow the ink to dry.

8 Intensify the shadows by adding a small amount of green to carmine in a 30:70 mix, adjusting it according to the intensity of the inks. Test a few versions on a separate sheet of paper first. Use the size 3 round brush and apply just a bit of this color on the shadows, seeds, around the highlights, and on the edges of the rind.

9 Intensify the shadow under the pomegranate with the mix from the previous step to add the feeling of space. If the edges are too sharp, blend them with clean water and a synthetic brush. These brushes have stiffer bristles, which allow you to lift and mix pigment better than natural brushes.

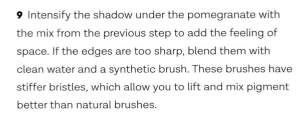

LESSON: CAFÉ DESSERT

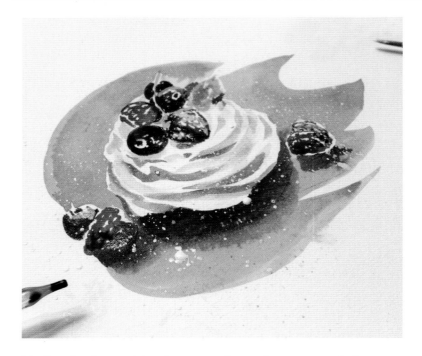

MATERIALS

Template (see page 124)

Pencil

Watercolor paper: cold press, 100% cotton, 300 gsm

Masking fluid

Old paintbrush for using with the masking fluid (**Note:** Some brands of masking fluid come with a fine-tip applicator that can be used in place of a brush.)

Colored inks (any type will work): turquoise, cobalt, purple, scarlet, neutral tint (see page 70), yellow-green, and white

Brushes: synthetic round, sizes 3 and 6, and a mop brush, size 1

Rubber cement eraser (optional)

My favorite dessert is Pavlova, a meringue dessert named after the famous Russian ballerina from St. Petersburg, which is my hometown. You'll paint this meringue while learning new ways of inking white space and adding special effects to create the look of powdered sugar.

1 Using the template, a reference image, or your imagination, create a pencil sketch of a Pavlova. An effective way to create a vivid illustration with a lot of white, like this one, is to place it on a brilliant background. Apply masking fluid with an old brush on the edges of the dessert and the fruit around it, protecting the white areas. Allow the masking fluid to dry. Alternatively, you can use another negative painting technique (see page 42).

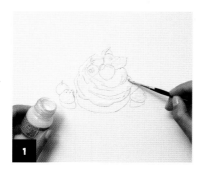

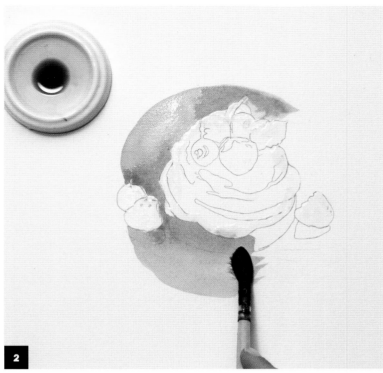

2 Load the mop brush with water and turquoise ink and paint a background with a few large circular brushstrokes, forming a round shape. Since the masking fluid is protecting the edges, you'll see the outline of the dessert clearly.

3 While the turquoise background is still wet, add a shadow under the Pavlova and the fruit around it using the size 6 round brush with a neutral tint or any dark color. The wet-on-wet technique provides a smooth effect, but be sure to use a small amount of ink to avoid having the color bleed into the background.

(continued)

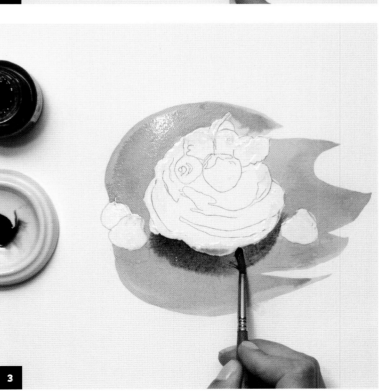

TIP

Pay special attention to colors when painting food. We're naturally drawn to appetizing and fresh shades of orange and yellow, which remind us of fruit. At the same time, blue and green shades may not be as appealing. Avoid using blue-green hues to paint food and drink, unless they truly are those shades.

4 Sculpt the shadow edge by sweeping the same round brush from edge to edge. To remove excessive ink or water, blot the brush with a paper towel and repeat the sweeping technique.

5 Remove the masking fluid with your fingers or a rubber cement eraser and start sculpting the meringue shape. Add brushstrokes to the dessert to create a three-dimensional form, using a light wash of neutral tint. With horizontal strokes and the size 6 round brush, paint shadows on the underlayers of the meringue, leaving the top parts white as highlights. The outlines of the shadows are indicated on the template, but you can ink just a few to get a general impression of value. Use a lighter wash on top of the meringue and create a wash that's twice as dark for areas closer to the base.

6 Load the size 3 round brush with cobalt and ink the blueberries. Create highlights by leaving small areas of white paper showing on the berries, imagining where a light source would be. Create shadows close to the edges by applying the second layer of undiluted cobalt ink on the opposite side of the highlights. Make the berries more realistic (even on a small scale) by leaving a small oval area at the top white.

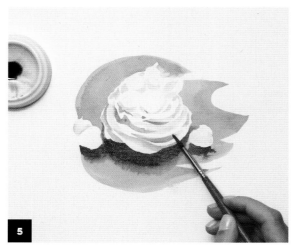

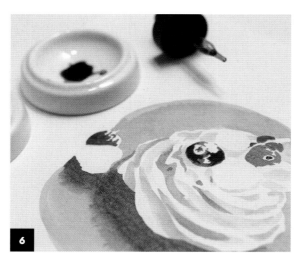

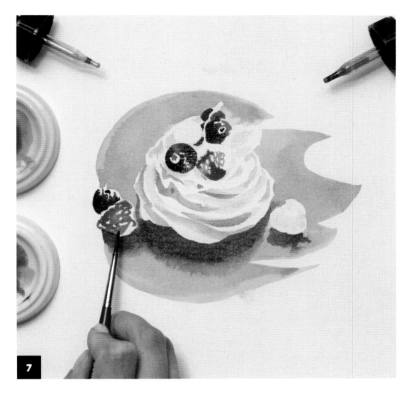

7 Ink the remainder of the berries using a 1:1 mix of scarlet and purple, or any vivid red shade. Leave tiny white dots on the raspberries (the white paper) to bolster the shapes and create shadows by adding green or blue ink to the edges.

8 Load the size 6 round brush with yellow-green and paint a leaf on top of the Pavlova. Add final touches, including refining the shadows and highlights, unifying the artwork. Allow the ink to dry.

Add the look of powdered sugar with ink and the spatter technique (see page 44)—my favorite part. Load the size 3 round brush with white ink and snap the brush against your finger. Tiny sparkles of white ink will fill the page, turning the image into a lively illustration.

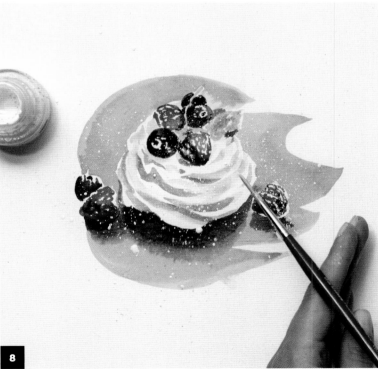

7

PROJECTS

Colored ink is a truly universal medium and can be applied to so many genres. In this chapter, you'll explore five art projects that will take your inking skills to the next level. You'll make a cork bracelet and a sculpted horse, decorate a tote bag, produce a modern paper doll collection, and create an accordion book inspired by *Alice's Adventures in Wonderland*. These pieces are fun and rewarding to create and make spectacular gifts. Unlock your imagination and see what you can create.

CORK BRACELET

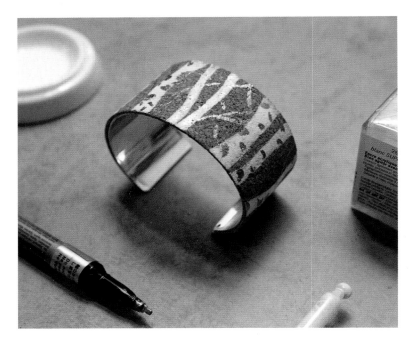

MATERIALS

Cuff bracelet blank, 1½" (3.5 cm) (found online or in craft or jewelry supply stores; for this design, choose the widest bracelet you can find to create the composition)

Self-adhesive cork sheet

Acrylic matte medium

White acrylic ink, highly pigmented

Brush: synthetic round, size 3

Gold metallic acrylic paint marker (preferably with a chisel tip) or gold metallic acrylic paint

Cutting mat

Metal ruler

Craft knife

Scissors

Cork is a natural material with unique properties. Most importantly, it's fully biodegradable, renewable, and recyclable—no wonder it's getting more popular among artists and crafters. In this project, you'll create a modern bracelet decorated with a birch tree motif.

1 Mark the width and length of the bracelet on the cork sheet. Coat the cork with a primer such as matte medium or clear gesso and allow it to dry. This step isn't necessary when working with acrylic inks, but it adds durability.

TIP
Always test acrylic mediums on surfaces you want to use. Transparent gesso seemed like a reasonable choice for coating the cork, but I discovered that it made the porous surface of the cork gritty. I used matte medium instead.

2 Paint the first birch tree silhouette with white acrylic ink, going from the top of the cork to the marked-off line. Paint a curved line about ¼" (6 mm) from the top of the cork strip to the bottom.

3 Create various birch tree trunks, slightly changing the shape and thickness of the trunks every time and making them curvy, almost as if they're dancing. As you paint, consider not only the white shapes but also the negative space. By making negative spaces interesting and balanced, you can create an impactful image with minimal effort. Remember the power of a silhouette, and that beautiful designs can be achieved with minimal shapes.

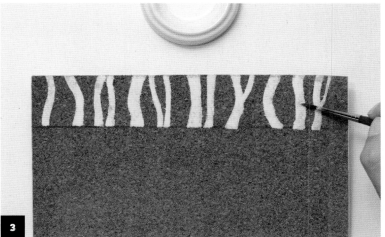

If the first layer is not opaque enough, apply a second layer with undiluted white ink; this will increase the contrast with the cork. Allow this layer to dry for about 30 minutes.

4 Add texture to the trees with a metallic paint pen. Dab the marker (or a brush, if using acrylic paint) on the trees, making irregular, asymmetrical marks. This helps create the look of birch bark in a unique way. The marker's chisel tip works well for making marks that add visual texture. Allow the paint to dry.

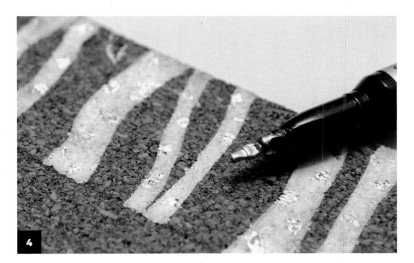

(continued)

5 Add tiny branches to the trees with the paint pen, paying attention to the perspective of the branches. Allow the paint to dry.

6 Measure the exact width of the bracelet and mark the cork with a pencil. Place the cork on a cutting mat and cut it along the line, cutting against a metal ruler with a craft knife.

7 Remove the backing on the cork sheet. Before adhering it to the bracelet, make sure the bracelet is clean and oil-free. Decide how you want to position the cork on the bracelet and adhere it, going slowly and making sure there are no air bubbles. Trim any overhang with a craft knife or scissors.

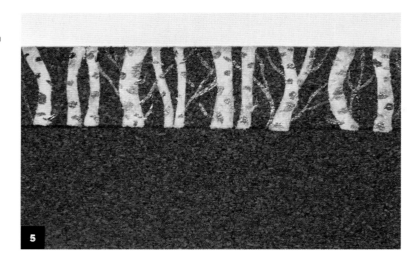

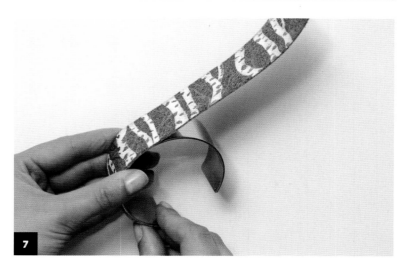

DECORATED SCULPTURE

MATERIALS

- - -

Air-dry clay in white

Clay molding tool

Universal primer or gesso

Acrylic inks: phthalo green, Indian yellow, primary magenta, cobalt, lemon yellow, ultramarine, and white

Palette

Brush: synthetic round, size 3

Gold metallic ink marker

Varnish, water based, spray or brush on (optional)

Add a new dimension to your inky projects and create a modern sculpture. You can make it from scratch, as I'll show you in this project, or paint a ready-made clay or ceramic object. Note that alcohol inks work on any surface, and acrylic inks can be applied to almost any surface if it has been treated with an acrylic primer.

Air-dry clay is easy to use for sculpting and hardens when exposed to air, so no oven or kiln is needed. You'll paint it with bright, cheerful abstract shapes, plus circles and dots in various colors.

1 Pinch off several pieces of clay and form ten balls of various sizes in the proportion shown. These will become parts of the horse. Estimating the size of the pieces is easier when they're in ball shapes, rather than randomly shaped chunks. I've made two large balls about 2" (5 cm) in diameter, four about 1" (2.5 cm) in diameter, and four smaller ones about ½" (1.3 cm) in diameter.

(continued)

2 Sculpt the clay balls into the ten parts of the horse: the body, head, four legs, two ears, tail, and mane. Sculpt the legs by rolling the four 1" (2.5 cm) balls between your hands, molding them into carrot shapes **(2A)**. Use the two largest balls to form the body of the horse and head by forming them into sausage shapes. Bend one sausage shape in an arc to create the head. Brush the shapes with slightly wet fingers to smooth the surface. Use the four smallest balls for the ears, mane, and tail. Create two small cone shapes for the ears. Roll out the remaining small pieces and twist them, creating the mane and the tail **(2B)**.

Feel free to interpret the elements in your own unique way. Work intuitively, adding or removing clay to match the proportions you envision. If the clay becomes too stiff, add some water to your hands and work it into the clay.

3 Put the ten parts together, connecting and leveling the edges as you go. Add a bit of water to smooth the edges and help the clay adhere. Use your fingers or a clay molding tool on some areas to make stronger connections.

Add texture at this stage or use water to create a smooth, slick surface. Add texture by scratching designs or simple marks into the clay with a molding tool or a toothpick.

Allow the piece to dry completely; this may take 10 hours or more, depending on weather and temperature conditions. The clay is dry when it feels room temperature to the touch. If the clay feels cool, it's still wet.

Note that as the piece dries, it will shrink slightly as the water evaporates.

2A

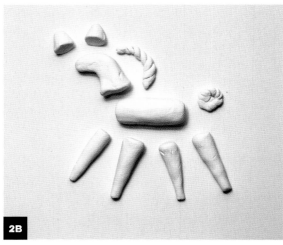

2B

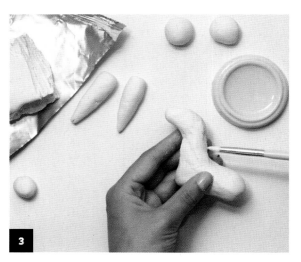

3

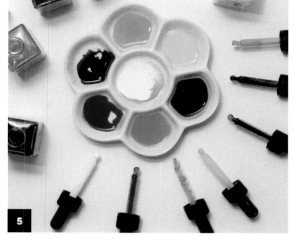

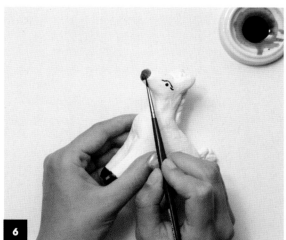

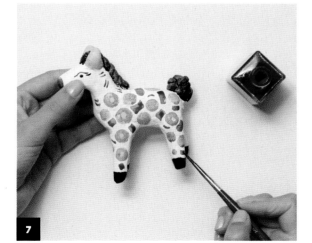

4 Apply universal primer to the piece. I used an indoor/outdoor primer, which works on any surface. Alternatively, you can use gesso. Read the instructions on the primer or gesso to see how much you should use and how to apply it. Let it dry completely.

5 Prepare the inks by placing some of each color in the wells of a palette; this will give you an overview of the color scheme.

6 Load the brush with violet ink (or mix primary magenta and ultramarine) and carefully paint the eyes, nose, and hooves. When painting the eye, think of an ancient Egyptian symbol. Use minimal and playful strokes. Apply ink to the mane and tail carefully, painting every curl. Remove any excess ink if necessary.

7 Paint the ears Indian yellow; this makes a great contrast with the dark violet mane. Add decorative circles and shapes on the body with cobalt. To achieve a lighter, more pastel color, mix cobalt with white.

Fill the brush with primary magenta and ink geometric ornaments and lines on various parts of the horse. Add blue circles with a drop of yellow in the center. Paint intuitively to create an individual piece!

(continued)

8 Add more decorative circles of various sizes to brighten the piece; I created small dots in mint (you can mix white ink with phthalo green). To intensify the contrast even more, add lemon yellow in the middle of the blue circles or near the violet elements. Add a few colorful lines on the forehead. Allow the ink to dry.

9 Add extra magic and sparkles. Add dots, curls, swirls, and marks of various sizes all over with a metallic gold marker. The cold gold pop on dark violet adds extra richness to the primary magenta. Allow the ink to dry.

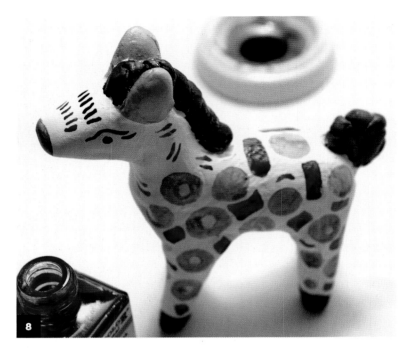

TIP

Consider varnishing your beautiful creation. A thin transparent layer of water-based varnish will seal and protect it from humidity. Varnish usually comes in three finishes: matte, glossy, and satin. I prefer using a glossy or satin-finish spray varnish. Always apply varnish outdoors.

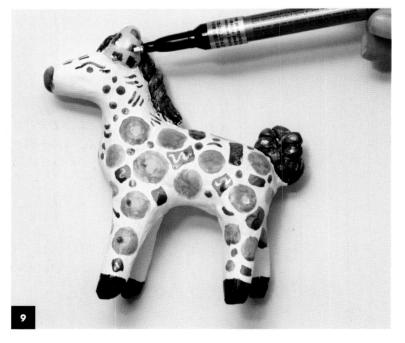

ABSTRACT ALCOHOL INK TOTE

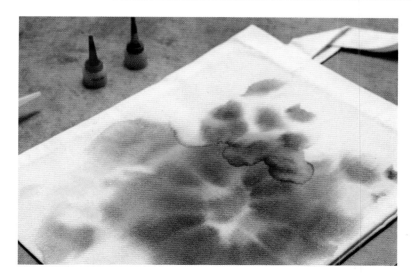

MATERIALS

- - -

Aluminum foil

Plain canvas or other fabric bag (these can be found at craft stores)

Large metal or plastic jar lid

Protective gloves (optional, alcohol inks are hard to wash off)

Alcohol inks: magenta, violet, and lemon yellow

Alcohol ink blending solution (to blend and dilute inks)

Alcohol ink markers (optional)

Spray varnish (optional)

You've probably seen alcohol inks used in techniques such as pouring, liquid painting, or for coloring resin. This ink's superpower is that it adheres to nonabsorbent surfaces such as glass and ceramics. You can also use it to color fabric. If you've ever tie-dyed fabric, you can imagine the possibilities of the medium.

In this project, you'll apply alcohol inks to a canvas bag to create a unique piece. The technique is super easy and can be applied to any household items, such as glass vases, ceramic bowls, metal utensils, porcelain, and fabric.

(continued)

TIP

Alcohol inks are also available in marker form, and they can be used on fabric and other surfaces, including glass, ceramic, fabric, foil, and coated or Yupo paper. Isopropyl alcohol can be used with the markers as a mixing, extending, or lightening medium. The consistency of the ink in the markers creates beautiful gradients and effects that can be developed further by adding more drops of alcohol blending solution and ink. You can draw with markers over an inked surface to create accents or add lettering, even when the artwork is finished.

1 Cut a piece of aluminum foil to fit inside the bag, then place it inside to prevent any ink from bleeding through. Place the jar lid inside the bag as well, on top of the foil. Alcohol ink is very thin and runny and can splash easily, so the lid collects any overflow ink under the fabric if you add too much while you're experimenting.

2 Put on protective gloves if desired. Add a drop of lemon yellow to the bag. Immediately after, add a few drops of magenta around the yellow. Add a round of violet drops, forming an outer circle. The whole process should take just a few seconds. Don't worry if the inks splash and spatter around—your design will look like a beautiful abstraction.

3 Drop or pour the blending solution directly onto the fabric in spots and see what happens. The changes will happen in an instant, diluting the pigment and creating a beautiful blurry effect.

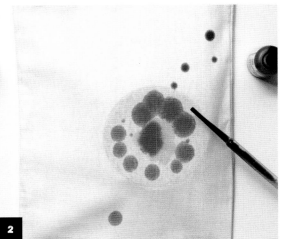

TIP
Concentrated alcohol ink right from the bottle delivers vibrant patterns and gradients. Diluted inks provide smooth and subtle color transitions. Mix ink and isopropyl alcohol in separate bottles to play with the intensity—you may end up with a unique color collection!

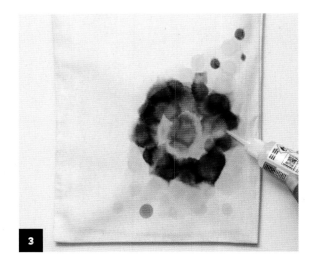

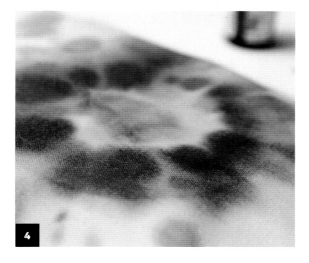

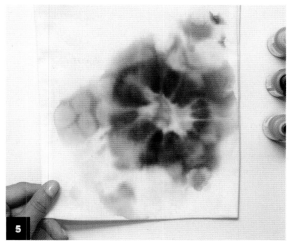

4 Increase the dark values by adding a few more drops of violet and notice how it blends beautifully with the magenta. Add drops of violet around the yellow center to add interest and variety, making sure to avoid mixing the two colors. As an option you can also use alcohol ink markers to add accents or draw patterns.

5 Add a few drops of ink here and there to harmonize the gradients if you feel like it. Remove the foil and jar lid from the bag and enjoy the incredible results.

You can use a clear spray varnish to seal the bag, protect it from UV rays, and fix the alcohol ink. Make sure the varnish doesn't contain alcohol, or it will react with the inks.

Note: Not all inks are washable. Check the manufacturer's washing recommendations or test a scrap piece of fabric to see whether the colors bleed when wet.

TIP

Alcohol ink blending solutions and extenders react with ink, resulting in smooth gradients. The solution blends and lightens alcohol inks, resulting in blurry effects. It can also be used to remove inks from smooth surfaces.

Alternatively, you can use 99 percent isopropyl alcohol, which reacts differently from blending solutions and extenders. It creates harder lines, evaporates faster, and doesn't blend inks as smoothly as a blending solution does.

ALICE'S ADVENTURES IN WONDERLAND ACCORDION BOOK

MATERIALS
- - -

Cutting mat

Craft knife

Ruler

Watercolor paper: cold press, 100% cotton, 300 gsm

Bone folder (see Tip, opposite page)

HB pencil

Binder clip

Shellac or India colored ink: violet

Brush: synthetic round, size 3

White pen

Acrylic inks: primary magenta, phthalo green, and white

Cardboard gift box (see Note, opposite page)

Molotow Liquid Chrome marker or metallic marker

The book *Alice's Adventures in Wonderland* has inspired endless interpretations around the globe. You can create your own interpretation of this adorable play on logic and imagination by making a whimsical accordion or zigzag book. Fill it with silhouettes of the main characters, applying some of the methods you learned earlier in the book. We'll use only three colors and a minimalist approach. The techniques are easy, and you'll be amazed by the results. Join me, and things will get curiouser and curiouser.

1 Decide which scenes or characters from the book you want to illustrate. I made a list of the six characters I find most memorable: the White Rabbit, Alice, Absalom the Caterpillar, the Cheshire Cat, the Hatter (more commonly known as the Mad Hatter), and the Queen of Hearts. The White Rabbit, known for holding his pocket watch, will work great as a cover.

2 On a cutting mat, using a craft knife and ruler, cut a long sheet of watercolor paper for the accordion book. You can make the book any size; I used an 18.8" × 6.5" (48 × 16.5 cm) piece of paper and folded it into six equal panels. Using a 2:1 ratio of height to width is helpful to determine the overall paper size. Fold the paper back and forth to create an accordion or zigzag and use the bone folder to firmly crease the paper.

If you don't have a piece of paper long enough to create six panels, make shorter accordions and glue the first and last panels together to make one continuous piece.

Note: If you want to enclose the book in a gift box, measure the box and size the book accordingly. Make sure that the height and width of the folded book is slightly smaller than the box, so it will comfortably fit inside. Alternatively, search for box templates online and create one to suit your needs.

3 With an HB pencil, sketch the White Rabbit outline using the template or your own inspiration and surround it with a few decorative leaves and plants from the magic garden. Draw the image on one panel or spread the image out over several panels. Continue sketching the characters and/or scenes. I use a binder clip to hold the pages together while I'm working.

(continued)

TIP

A bone folder is a special tool used in bookbinding to fold and crease the pages. Use the edge of the bone folder to create a crisp crease. Most bone folders are made of cow bone, but you can find ones made from wood, plastic, and Teflon as well. Objects with firm, straight sides, such as rulers, knives, or spatulas, can be substituted.

4 Ink the characters in violet, using a small brush. Create silhouettes, leaving some areas unpainted so you can add details and accents later **(4A)**.

For example, you can emphasize the fact that Alice is looking at the key curiously by using another color. You'll do that in a later step, but at this stage I'm thinking about which tiny objects or costume pieces can be inked to contrast with the first color to attract attention. The same technique works well for parts of the garments and the accessories of the other characters **(4B)**. For example, the Queen's dress will look more attractive if a pattern of tiny hearts pops, due to adding bright pink on deep violet. The Hatter's scarf or coat can be decorated with little white dots by leaving the paper white or by inking them with an opaque white pen on top of the dried violet layer. A few pink ovals on a colossal mushroom will visually balance the position of the Caterpillar, with his pink smoke circles.

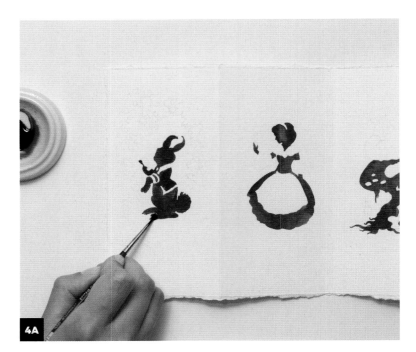

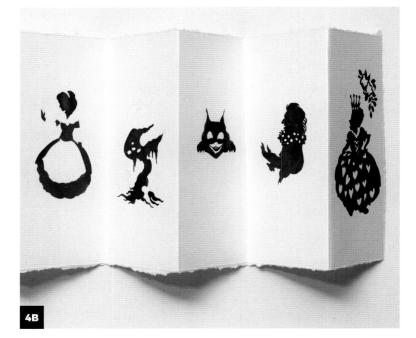

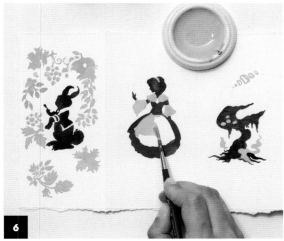

5 Mix primary magenta with white to create pastel pink, which contrasts with violet. Use it to paint the foliage surrounding the White Rabbit. This unusual color choice symbolizes the imaginative events that happen in the book.

6 Use the pastel pink to paint other elements, aiming to unify and harmonize the design. Alice's dress, the smoke from the Caterpillar's hookah, tiny dots on the mushroom—all of these tiny components add to the whole and create a world with its own rules. Allow the ink to dry.

7 Mix phthalo green with white to create a pastel mint color to match the pastel pink. Since this hue is the brightest one, it should be used as an accent only, as we learned earlier (see page 28). The unique Caterpillar, however, is an exception, so use it to color the shape.

(continued)

TIP

Combine various shapes of greenery in one illustration to add interest. For example, put round grape forms near long leaves, and combine heavy masses of bushes with subtle elegant lines of ivy. The diversity of forms rendered in silhouette can make your artwork stand out.

8 Continue painting and adding elements to the other characters, using all three colors. The Queen of Hearts has a lot of details and is surrounded by a few falling cards. Paint her face in profile to show her traits and emotions.

The Cheshire Cat is more effective rendered straight on so we can see the direct look of his hypnotic eyes. Has his tail disappeared already?

The Hatter is drinking tea. Paint the cup and the hat in the air to show the lunacy of the tea party. Add interest by creating white dots on his coat by leaving small spots unpainted, or by adding dots later with a white pen.

Complete the illustrations and allow the ink to dry.

9 Cut out a window in the box lid, using a craft knife and cutting mat. You can also buy a gift box with a lid and window, as I did here. Consider the shape you want— you can create an ellipse, or even a keyhole. Decorate the lid around part of the window with a chrome or metallic marker, creating abstract elements.

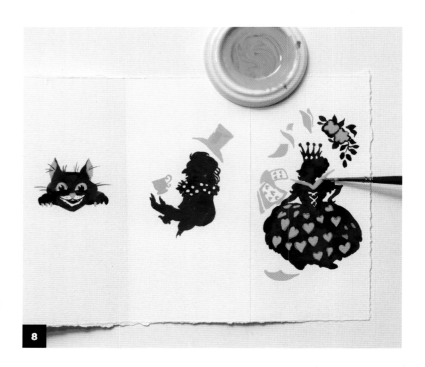

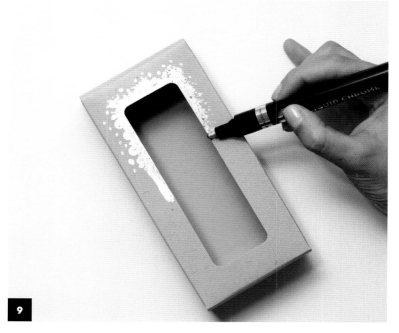

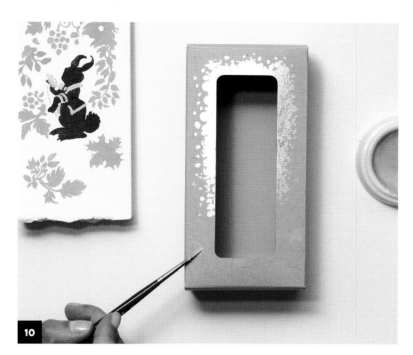

10 Using the foliage illustrations as inspiration, add motifs around the rest of the window with pastel pink. These botanical elements will complement the ones surrounding the White Rabbit.

11 Place the book in the box and see how they look as a set. Add a few leaves here and there on the box to balance the overall design. Enjoy holding this treasure in your hands!

TEMPLATES

Lesson: Cat Silhouettes

See page 41.

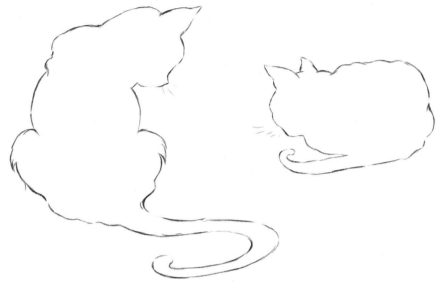

Lesson: Flower

See page 56.

Lesson: Butterfly

See page 68.

Lesson: Colorful Bird

See page 70.

Lesson: Red Panda

See page 73.

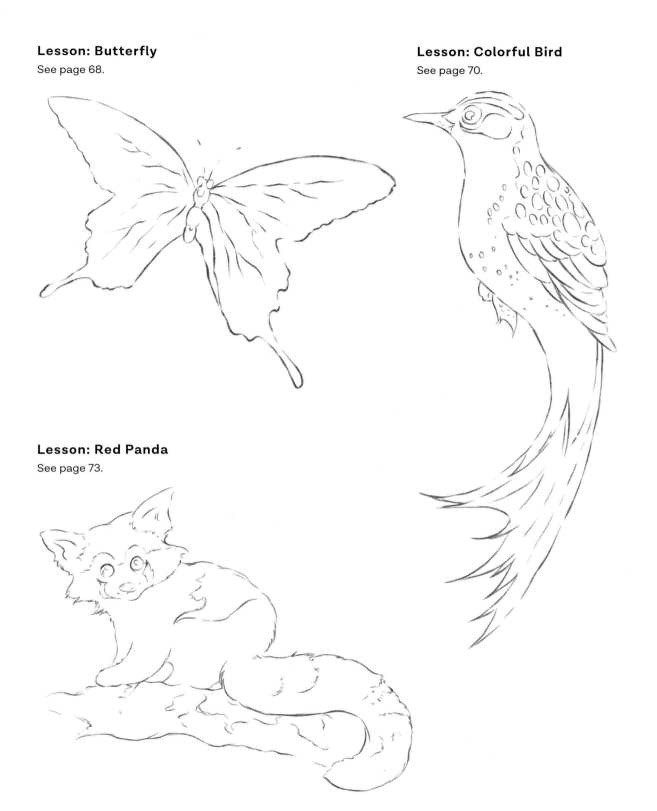

Lesson: Expressive Portrait

See page 87.

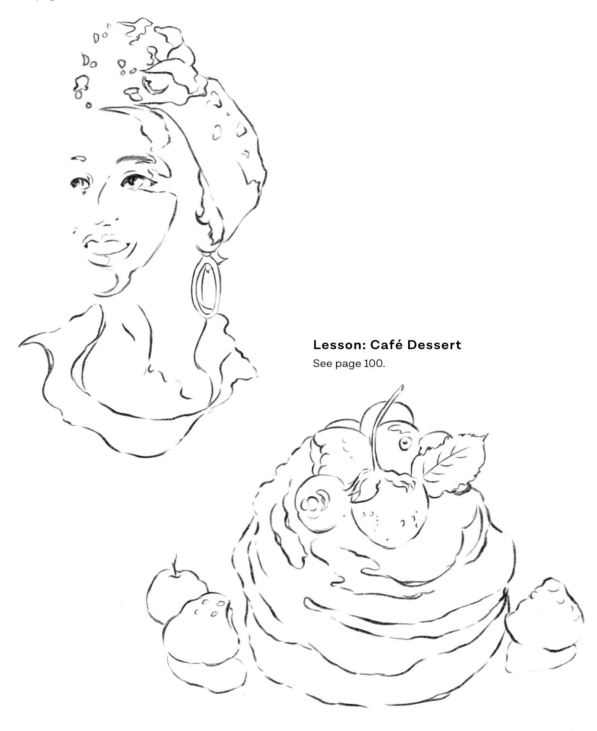

Lesson: Café Dessert

See page 100.

RESOURCES

My Online Classes
- Skillshare: skillshare.com/user/plushbrush
- My Modern Met Academy: mymodernmet.com

Take part in inky creative challenges. I host hashtag #INKredible_Inktober every year during the month of October; this tribute to Inktober (a yearly challenge started by artist Jake Parker) is a monthlong creative challenge dedicated to working with ink and improving drawing skills, regardless of your level. Ten prompts inspire the artwork, and prizes are included. The only rule is to make an inky artwork based on the prompts and share it online. You'll discover inspiration and support from the global art community.

Online Art Communities
- Urban Sketchers: urbansketchers.org
- They Draw: they-draw.com
- Spoonflower design challenges: spoonflower.com/design-challenge
- Mermay: mermay.com
- The 100 Day Project: the100dayproject.org

Websites with Copyright-Free Photos
- Unsplash: unsplash.com
- Pexels: pexels.com
- Pixabay: pixabay.com

Art Supplies

PAPER
- Hahnemühle: hahnemuehle.com

INKS
- Sennelier: sennelier-colors.com
- Schmincke: schmincke.de/en
- Rohrer & Klingner: rohrer-klingner.de
- Dr. Ph. Martin's: docmartins.com

BRUSHES
- daVinci: davinci-defet.com/englisch
- Escoda: escoda.com

ALCOHOL MARKERS
- Tombow ABT PRO: tomboweurope.com/en

MARKERS AND FINELINERS
- Sakura: sakuraofamerica.com
- Molotow: molotow.com/en

ACKNOWLEDGMENTS

I want to thank the whole publishing team at Quarto for their excellent and thoughtful hard work and brilliant ideas. Special thanks to my amazing editor Jeannine for being a supportive, intelligent, and creative guide in this new adventure. And to wonderful Marissa, for putting so much precious energy and ideas into the imagery. You've made this book possible!

I'm unbelievably grateful for my family, who always cherished personal freedom and celebrated creativity. A very special thank-you to my husband Maxim for years of support, inspiration, ingenious advice, and never-ending inventive discussions of creative ideas, be it walking in the rain in St. Petersburg, Paris, or Berlin.

I'm particularly grateful to my amazing friends for their help with the book and my creative journey. Anya and Nikita, for sincere support, enthusiasm, comprehensive knowledge, humor, and lively minds; Anastasia Dubrovina, for being a constant source of exceptional aesthetic treasures, sharing a *sui generis* look at things, and always being a secret mage for me; Svetlana Borodina, for expressive interpretations of starry beauty; and Sonja Danowski, for letting me in her mesmerizing world and showing what a talented artist with a unique vision can achieve.

I'm incredibly grateful for my students and fellow creatives who gifted me with their time and trust, the most valuable of all resources. Your support means so much to me. Thank you for every small project and sketch you shared online based on my courses and challenges. Your feedback, discussions, collaborations, and enthusiastic endeavors have impacted me more than you can imagine. Even if you never said or commented on anything, I know we share the same passion, and I hope that my artwork added a tiny sparkle to your starry sky.

We've created a lot of magic together, and it's only the beginning!

Thank you!

ABOUT THE AUTHOR

Anna Sokolova is an award-winning contemporary artist who loves to combine traditional and innovative approaches in art. She has received numerous industry awards, including winning the World Illustration Award for her signature Delft Blue series for Netflix. Esteemed collaborations include Tombow, *Wired* magazine, and Maison Margiela, among others.

Anna's work combines beautifully drawn, almost idyllic imagery with a slightly visible darker undertone. The intriguing choice of subject matter and modern Delft Blue style resulted in a collaboration with John Galliano in the film *A Folk Horror Tale*, featuring an artisanal collection for Paris Fashion Week.

Anna loves to share her knowledge by producing educational content for Skillshare, *ImagineFX*, and others. Her work is regularly featured in magazines and international exhibitions.

Born in St. Petersburg, Anna is inspired by Dostoevsky, symbolism, folk art, and Ballets Russes. She now lives in Berlin.

www.annasokolova.eu
@annasokolovaartist

INDEX